hollywood dreams

AN EXPLORATION OF THE MOTION PICTURE INDUSTRY
AND ITS CULTURE IN INDIA

bollywood dreams

BY JONATHAN TORGOVNIK

for Tali

a way of life

An Introduction to Indian Cinema by Nasreen Munni Kabir
6–7

the touring cinema
8–25

on the set
26–53

the characters
54–87

at the cinema
88–115

A Way of Life: An Introduction to Indian Cinema
by Nasreen Munni Kabir

Indian movies have a curiously infectious quality and have held a special place in Indian life ever since the birth of the Indian movie industry in 1913. Nothing in today's Indian popular culture is as pervasive as Bollywood movies – the Hindi and Urdu commercial films made in Mumbai (formerly Bombay) – with their distinctive approach to storytelling. Usually woven together by six songs and at least two lavish dance numbers, the movies are about unconditional love, the conflict between fathers and sons, revenge, redemption, survival against the odds, the importance of honour and self-respect, and the mission to uphold religious and moral values – grand themes that Hollywood generally leaves to the now rarely produced epic. Not so in India, where film directors routinely tackle the big questions head-on, even when making a formulaic run-of-the-mill entertainer. It is this particular kind of storytelling that has offered people of Indian origin their most beloved form of popular entertainment.

Bollywood movies are characterized by a selective number of cinematic ingredients that are reworked in each film. Indeed, repetition is part of the often predictable plots. To satisfy an audience, however, the right buttons must be pressed. These include great performances by glamorous stars; melodious, rhythmic music; exquisite sets and exotic locations. How the audience responds to the weaving together of these ingredients determines whether or not a film will be a blockbuster hit. Other key ingredients include elaborate, loud action scenes and a sense that the social or moral order will not be challenged. A happy ending is a mandatory requirement to conclude the two-and-a-half to three-hour movies.

The majority of the moviegoing audience in India consists of young men from a variety of regional, linguistic, religious and social backgrounds. Today there are around 500 million Indians under the age of twenty-five, out of a total population of over one billion, and films are made primarily to appeal to this age group. But of course, for a film to be genuinely popular it must also entertain the whole family, from grandmother to grandson, all of whom may also be avid moviegoers.

Watching a movie in an Indian cinema hall is a lively experience. The audience makes itself seen and heard at every turn of the plot – whistling at a sexy 'wet saree' number, egging on the hero as he takes on ten bad guys, and applauding melodramatic dialogue about lost values. Once it becomes clear that there will be a happy ending, the audience often does not bother to wait for the last scene but starts making its way out of the cinema before the film actually finishes. However, it would be wrong to assume that Indian audiences are passive consumers of whatever Bollywood offers. In fact, fewer than eight out of the more than 800 films made each year will make serious money (India is by far the world leader in terms of the sheer number of films produced).

Presented in a seamless mix of Hindi and Urdu (the two north Indian sister languages understood by over 400 million people, about half the population of India), the classic Bollywood movie may appear simplistic.

Even the familiar boy-meets-girl saga, however, can contain many layers of Indian culture, manifested in some form or other relating to class, religion and tradition. Popular cinema in India may borrow plots from Hollywood, but these are so transformed by the must-have ingredients of the Bollywood film that only the bare outlines of the originals can be discerned.

This sense that every film must address the theme of what it means to be Indian or reflect Indian thinking can be traced to the beginnings of Indian cinema. The early silent films were based on well-known Hindu epic tales from the *Mahabharata* and the *Ramayan*. The first cinema audiences loved seeing familiar mythological stories involving gods combating demons brought to life on the screen. The new Western invention was perfectly suited to the Indian context of storytelling which relied on oral tradition. The fact that cinema techniques, such as special effects or low-angle shots, could enhance the mythical was seen as a great asset in the telling of heroic tales. This remains a major reason why Bollywood films continue to capture the popular imagination in India.

Theatrical forms such as *Ram Leela*, an enactment of the exploits and adventures of Ram) and *Ras Leela* (based on the exploits of Krishna and episodes from his life) have had a great impact on the evolution of Indian cinema. This is still apparent both in the way music and drama work together and in the portrayal of the stock characters of Indian cinema. The villain, for example, is still given a curling moustache and a sinister laugh, an instantly recognizable version of the stage demons associated with *Ram Leela*. Early film screenings from 1913 onwards took place in tents beside temples in villages and small towns, where, after prayers, devotees made their way to see Lord Ram or Lord Krishna come alive on the screen.

Such devotion can still be seen in the hero-worship accorded to Bollywood stars. People want to act, talk and look like their idols. Barbers down the decades have been asked to give their customers an Ashok Kumar, Dilip Kumar or Shahrukh Khan cut, and tailors have been told to copy the clothes of the beautiful Madhubala or Aishwarya Rai. Until the early 1990s, star gossip was almost exclusively reported in India's dozens of film magazines, but interest in the world of cinema is now so extensive that virtually every daily newspaper devotes substantial space to who is doing what in Bollywood.

The style, content and pace of Indian movies have changed greatly over the years, as has the way in which the film industry operates. The studio era ended in the late 1940s, and freelancing became the norm in cities where the bulk of Indian films continue to be produced, including Mumbai, Calcutta, Chennai (formerly Madras) and Hyderabad. Erratic start-stop shooting schedules and complex financing have meant that, from the stars, music directors and choreographers at the top down to the lowest paid technicians, people work on several productions at the same time. The leading music director A.R. Rahman commented, 'How do I know that the film I'm working on will ever get released? Or even how long it will take to be completed? So I have to compose several soundtracks at the same time in order to make a living.' This juggling

of many projects has become commonplace since the 1960s, and no one is surprised when a star travels from one set to another, playing a cop in the morning and a psychopath in the afternoon.

Other key players are the action scene directors and the set and costume designers. There is a huge demand for exciting action scenes, as this has great appeal for young male audiences. Yet there are only a handful of action directors (known as 'stunt masters' in India) working in the film industry. Stunt masters involved in any one film are usually members of the same family and, like the stars, work on several films at the same time. This is also how the relatively few set and costume designers work. In a Bollywood movie, set design can range from the rickety and makeshift to the elaborate and lavish. Costume design has always been important, but never as much as it is in today's culture of glamour and beauty. Bollywood designers have become so trendy that many create exclusive wedding clothes for the ultra rich as a sideline.

Budgets today are higher than they have ever been, with star fees tripling costs. This has put a lot of pressure on filmmakers to succeed at the box office. It is no coincidence that Indian cinema had its golden age from the 1950s to the mid-1960s, at a time when budgets were generally lower and directors were encouraged to be inventive rather than play safe. Even minor films of this period have a special quality, whether it is a stunning romantic scene, an atmospheric song sequence, or a fabulous performance by Dilip Kumar or the comedian Johnny Walker. The era produced immensely popular stars and fine directors, of whom the most influential on the aesthetic of Indian cinema were Mehboob Khan, Bimal Roy, Raj Kapoor and Guru Dutt. These extraordinary filmmakers worked within the conventions of Indian cinema while making deeply personal classics. They set the standard, not only in their choice of theme and subject, but also in their approach to black-and-white photography, set design and editing. They avoided the usual stereotypes and stock figures, and the layered psychology and sophistication of their heroes and heroines have given Indian cinema its most enduring characters. These directors mastered the use of film music and choreography. Their song sequences rival the best in world cinema and in many cases surpass the Hollywood musical in their subtle linking of dialogue and lyrics. These directors transformed the film song into an art form and confirmed that music was Indian cinema's greatest strength. Even today, Indian filmmakers are aware that their moment of cinematic glory may well come from the songs. During every decade since the 1950s, a large number of films that would otherwise have been forgotten have been saved by a marvellous musical sequence in which melody, lyrics, cinematography, choreography and performance combine to magical effect.

After the golden age of the 1950–60s, the form of popular films started to change. By the 1970s, Hindi films began to combine all genres into a single movie, with song and dance firmly at the heart of the narrative. This 'mixed' approach is still the way the stories unfold today. In a Bollywood movie, such mixing and matching can translate into the hero fighting a sinister politician in one scene and serenading his heroine, with forty dancers moving in unison behind him, in the next.

Despite the popularity of television in India since the early 1990s, there is still a demand in the remoter areas of the country for touring cinemas, which involve a projectionist travelling in a truck with an assistant, eighteen reels of film and a tent that he will set up in the village. In nearly every city street, too, there are signs of Bollywood's influence. Postcards of the current movie heart-throbs are proudly displayed for sale on pavement stalls next to images of the most revered gods and national icons such as Mahatma Gandhi and Mother Teresa. At nearly every major roundabout and road junction – anywhere where there is space for a large billboard – gigantic hand-painted images of stars stare down at the passing traffic. Outdoing Mumbai in this respect are the cut-outs and billboards that line the streets in south India, where the popularity of stars is such that in recent years the leading names of Tamil and Telugu cinema have successfully transferred their appeal from screen to voting booth and have become chief ministers in Tamil Nadu and Andhra Pradesh.

Nearly every Indian, whether living in a village or a city, feels connected to the movies in some way either because they love a star (Amitabh Bachchan has broken all records with his fan following) or because of their love of film songs. The Bollywood movie is also an active link to home-land culture for those who have made Europe, the United States or Canada their home. When a movie with an A-list cast, such as *Lagaan* (Ashutosh Gowarikar, 2001) or *Devdas* (Sanjay Leela Bhansali, 2002), is released, people of Indian origin, whether they live in Lucknow or Leicester, head to the cinema at virtually the same time. Impassioned fans can also be found in the Middle East, Russia, China and many parts of Africa. Indian cinema is unique to Indian culture and history. At the same time, its energetic style, the emotional appeal of its themes, the glamorous lifestyles it portrays, its enduring melodies and lush settings all contribute to its increasing popularity world-wide. Jonathan Torgovnik's lyrical photographs show us the human face of Indian moviegoers, as well as those working behind the scenes, who together have made Indian cinema as alive as it is today.

the touring cinema

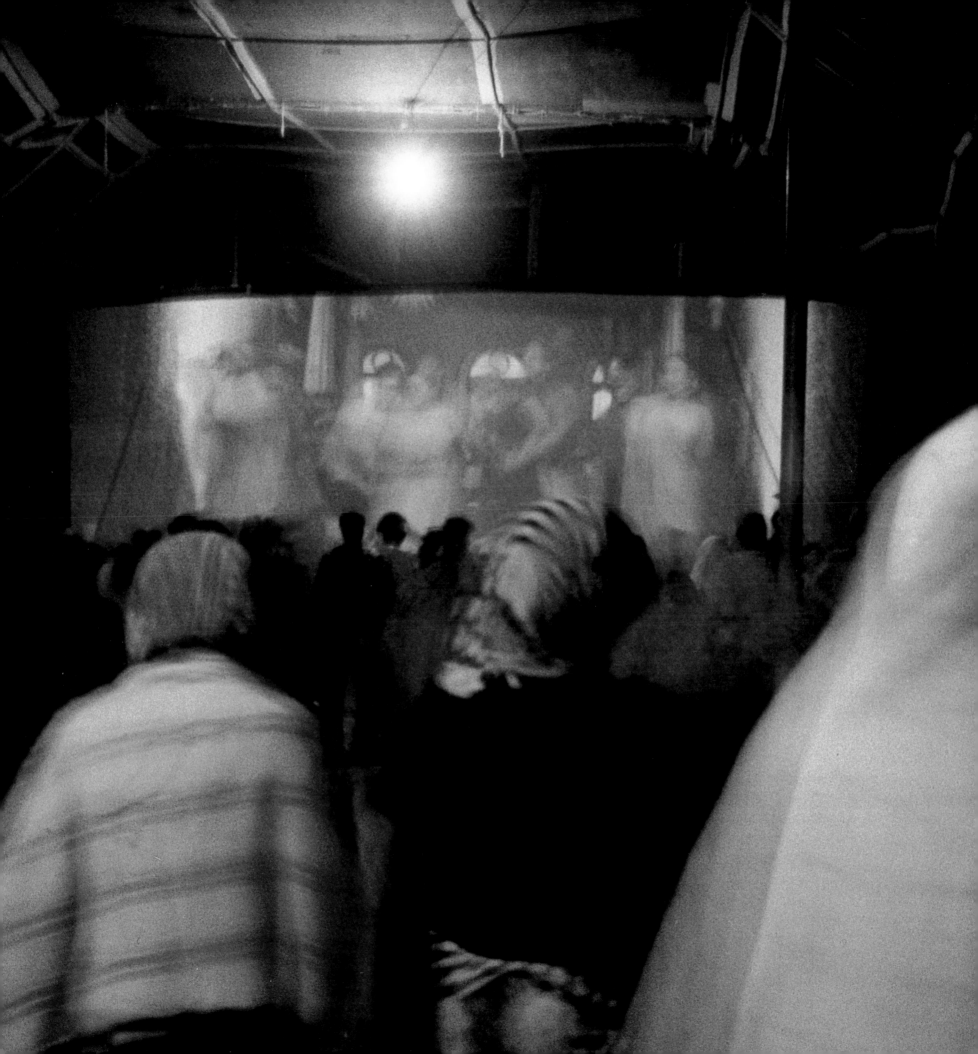

Amar Touring Cinema on the road between the villages of Pussegaon and Palli in the state of Maharashtra. It is one of the few remaining mobile cinemas in existence

Right: Kisan the projectionist sits on the cinema truck

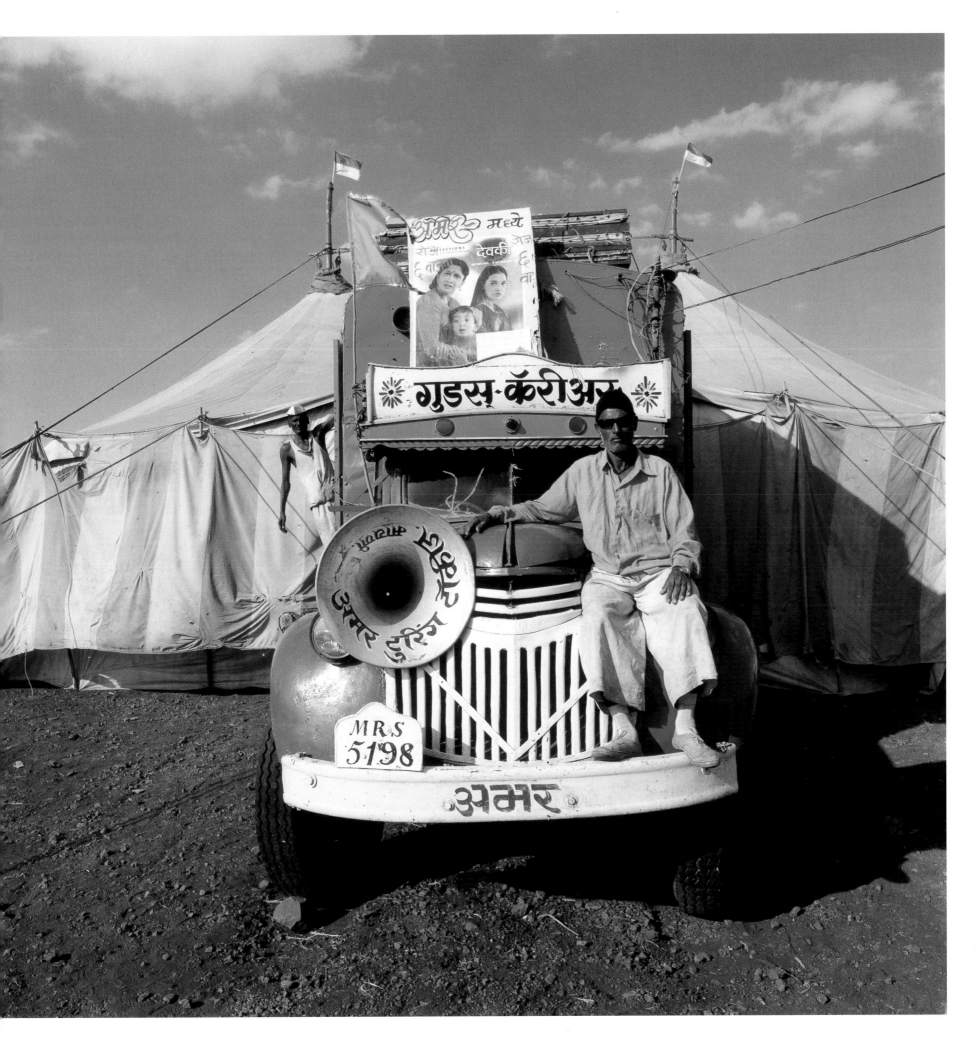

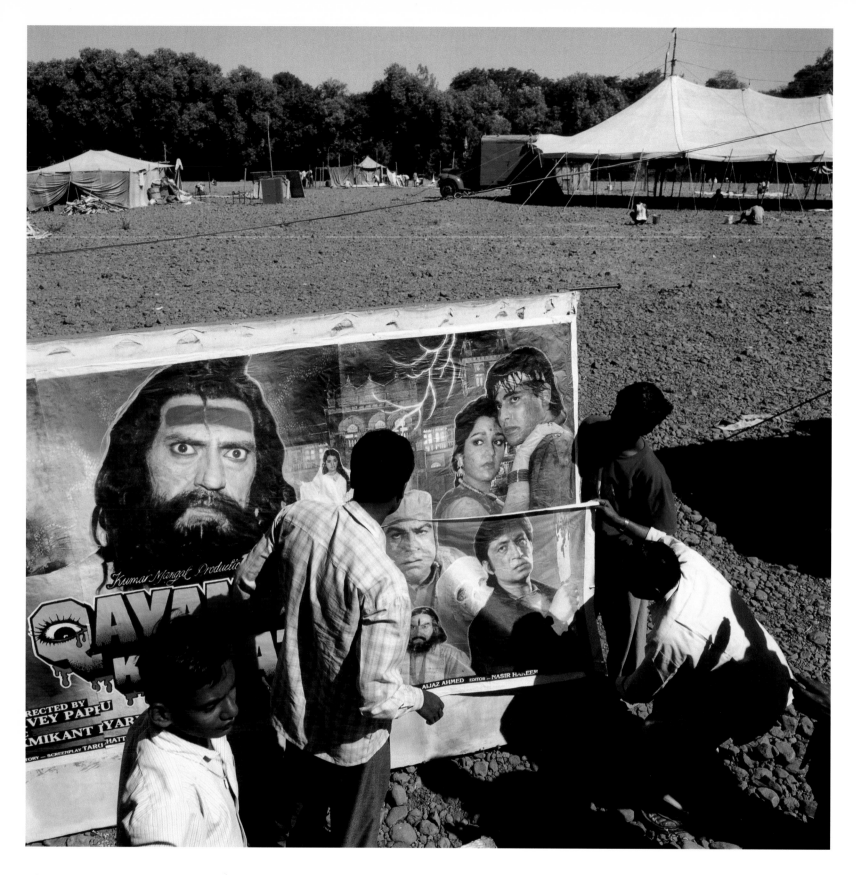

The touring cinema arrives at the village with three films
to show. Crew members advertise the next show with
posters in front of the cinema's tent.

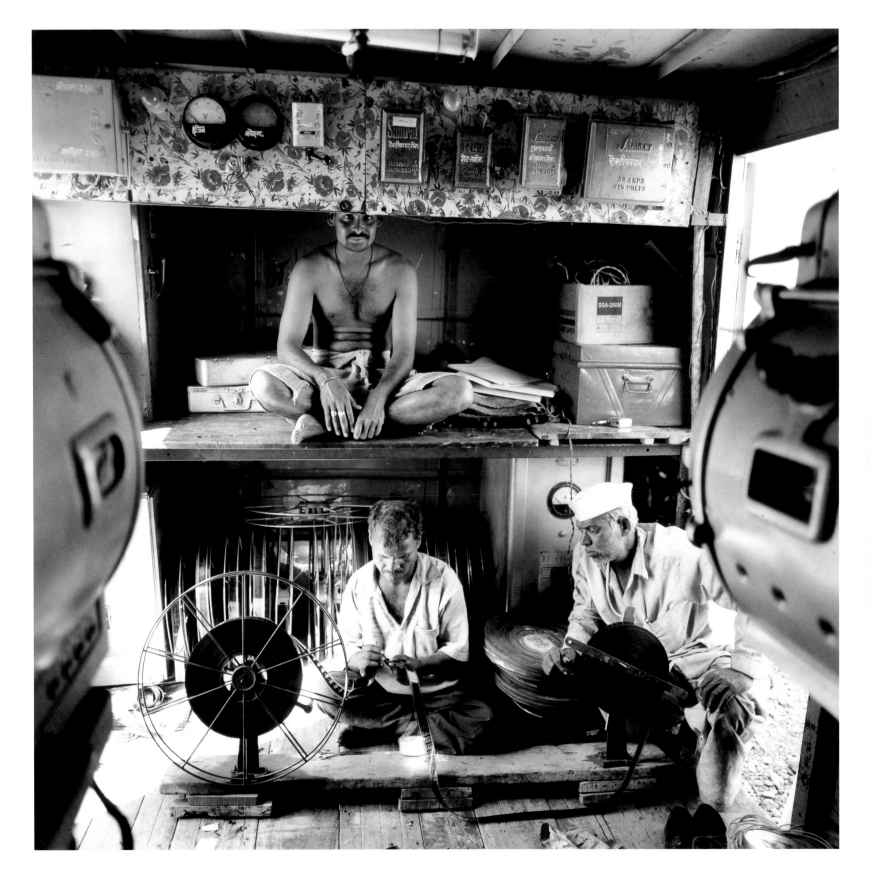

One of the projectionists fixes a torn reel of film before
the show starts. The touring cinema's two projectors can
be seen in the foreground.

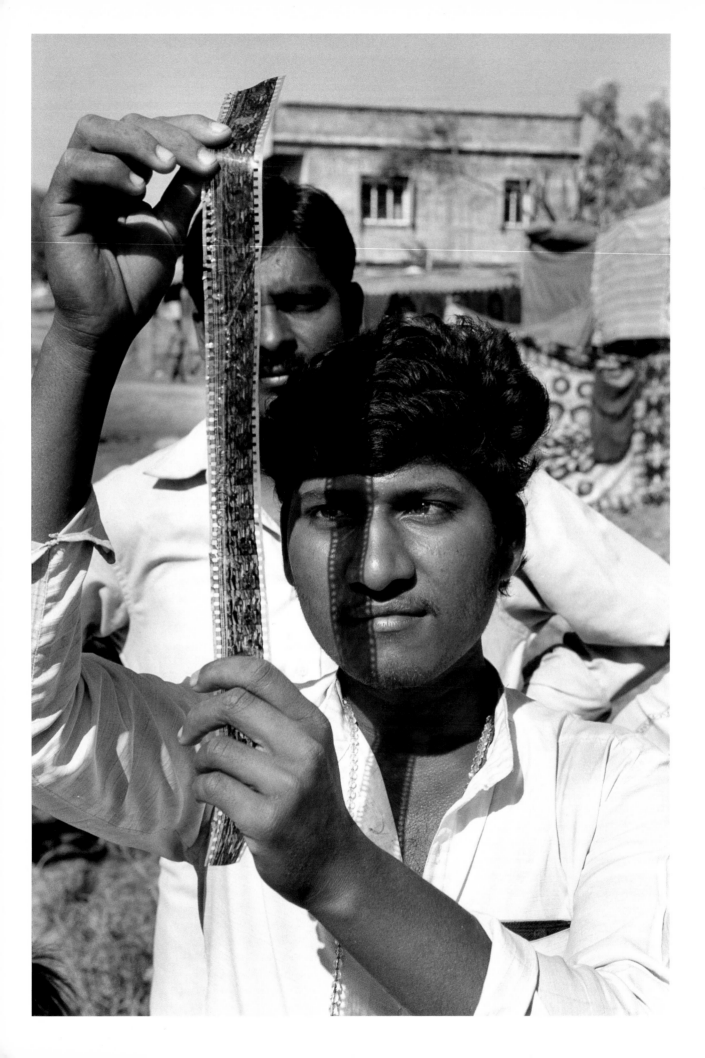

In the village of Pussegaon, a young man examines a film strip left by the touring cinema, hoping to find an image

Right: A crew member of the Amar Touring Cinema rewinds film reels between shows by the riverbank where

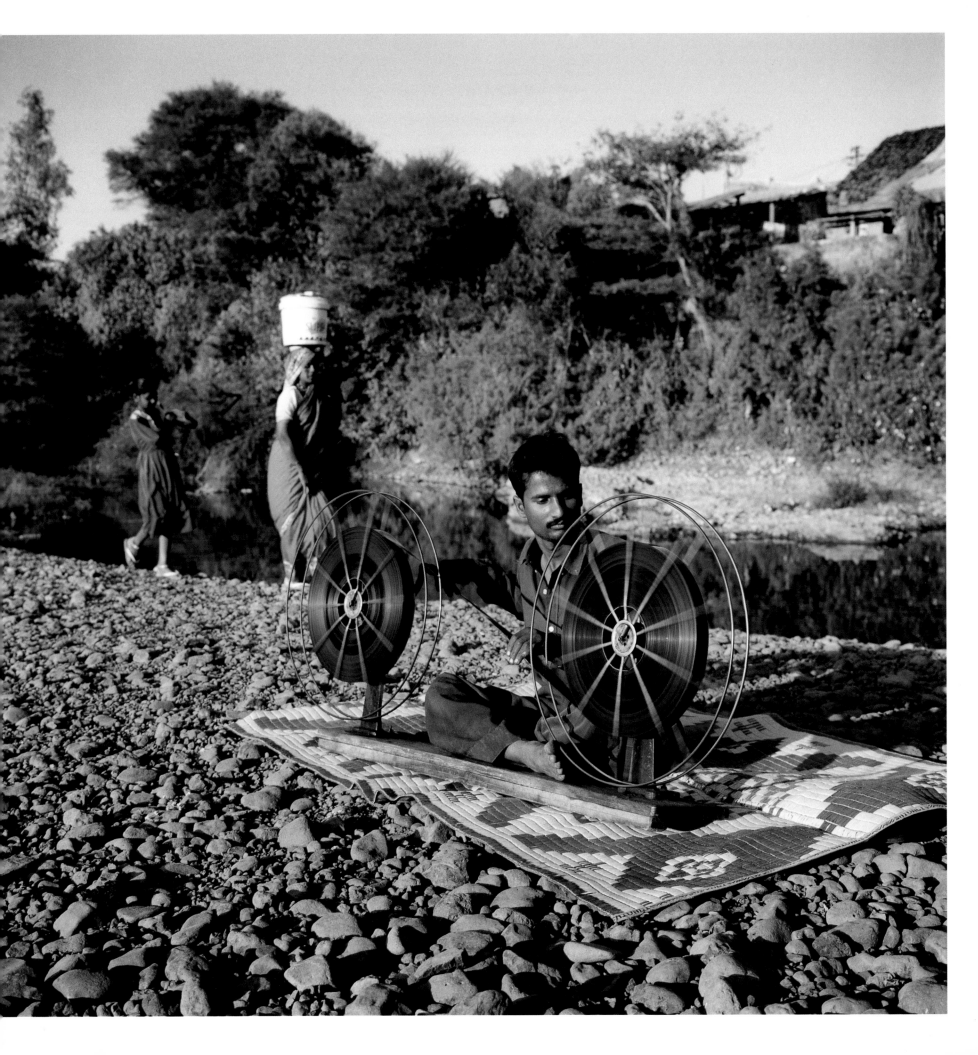

Metal ticket booths are set up near the tent of the
Amar Touring Cinema. A young boy purchases a

Right: Eager to enter the cinema, a group of young men
wait for the previous screening to end. For some it will

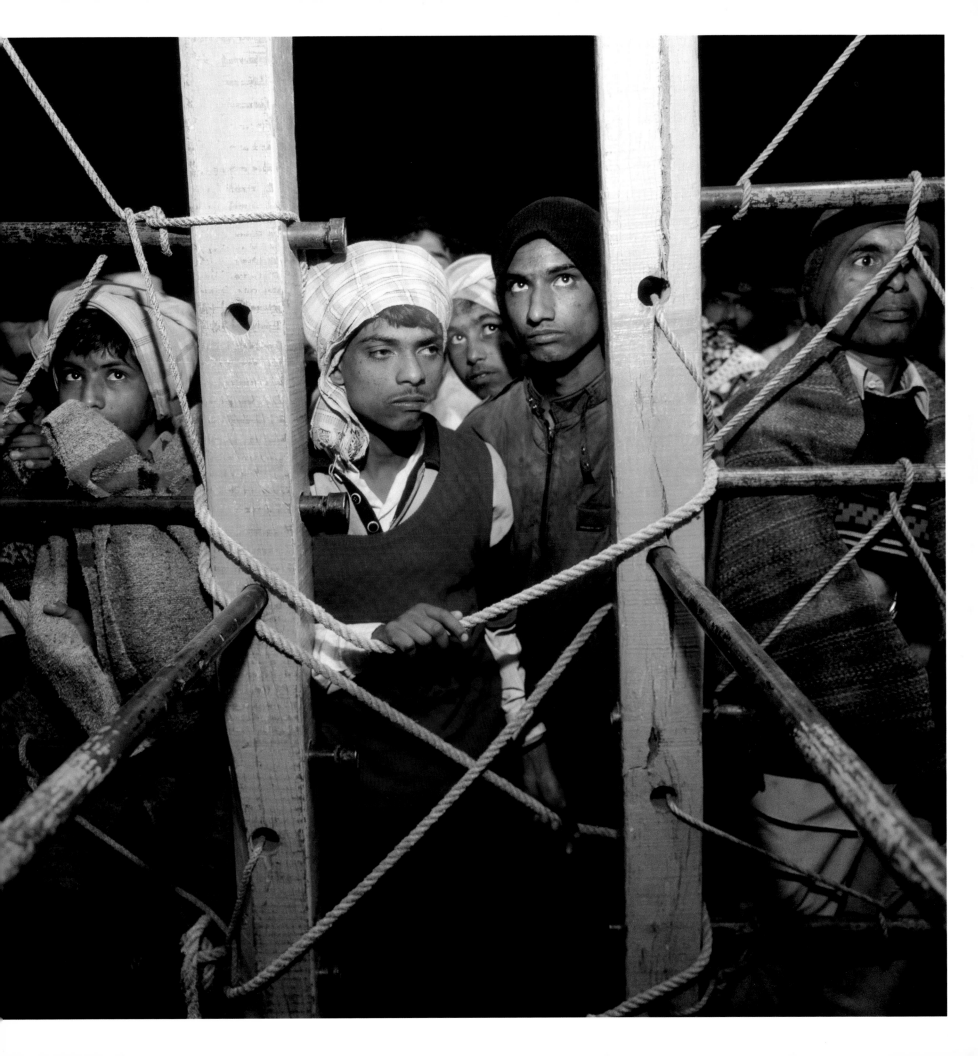

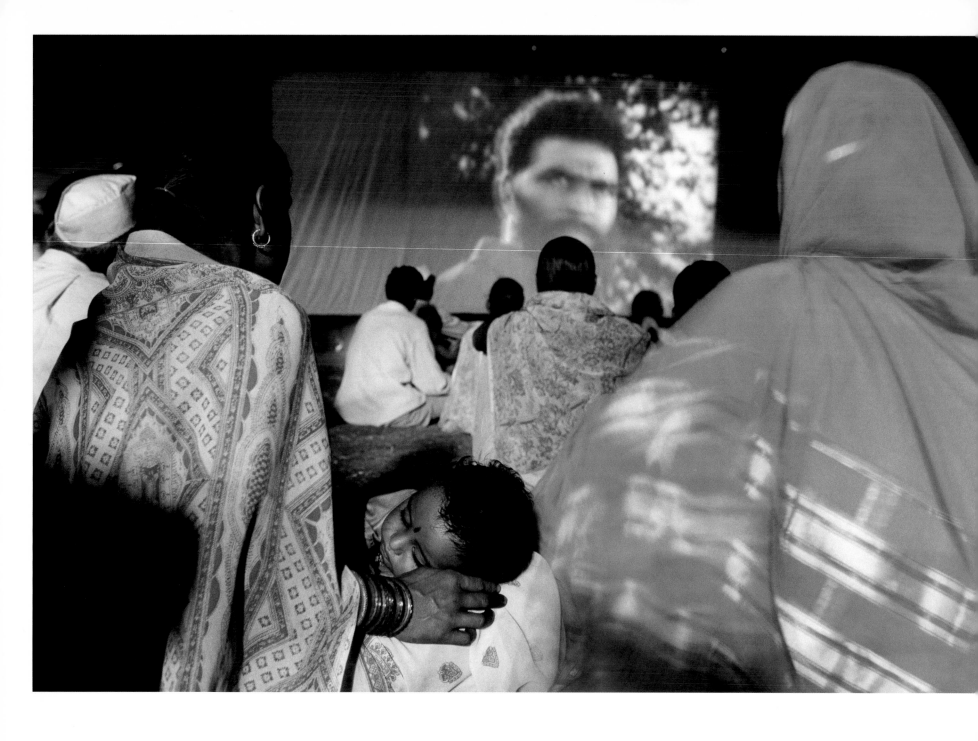

Family-oriented films attract mostly women with their children, while action films are normally geared to a male audience.

Right: The interior of Amar Touring Cinema's tent. At many shows, including this 12 noon screening, audiences can number more than 1,000.

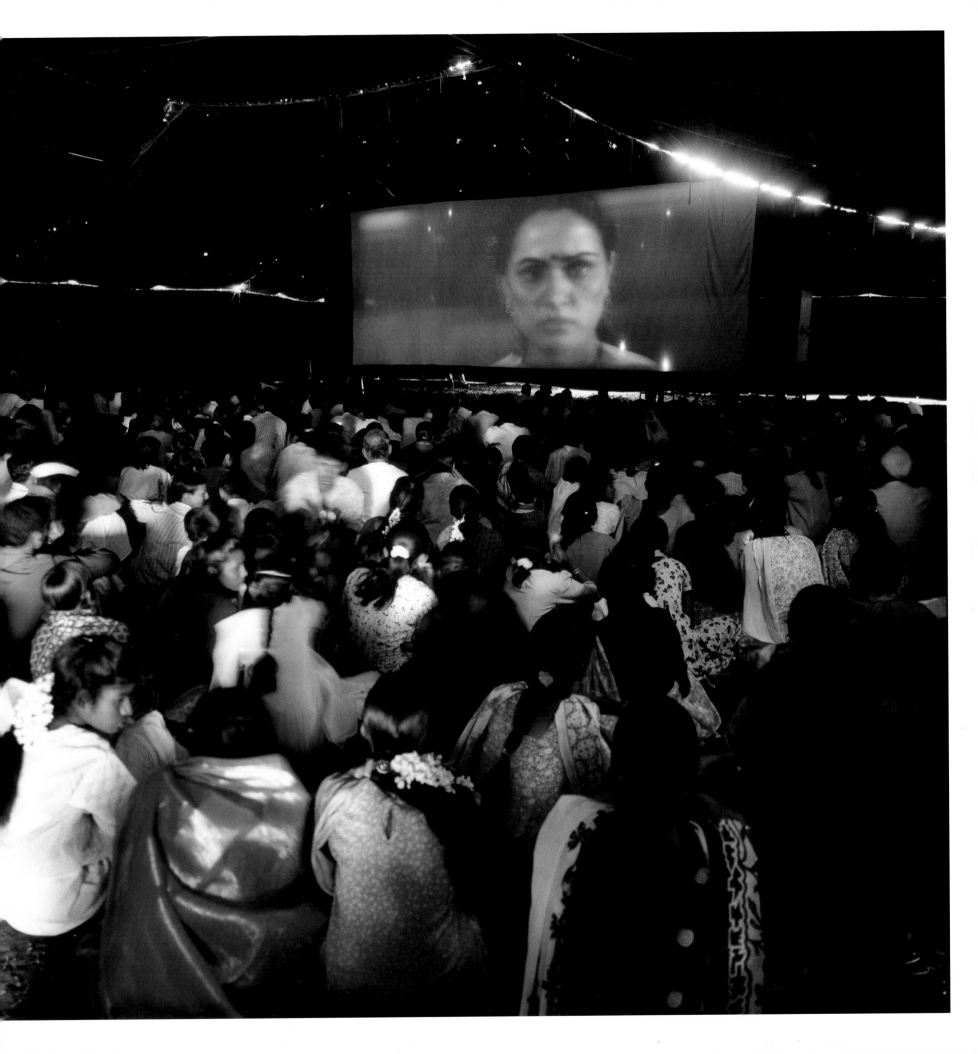

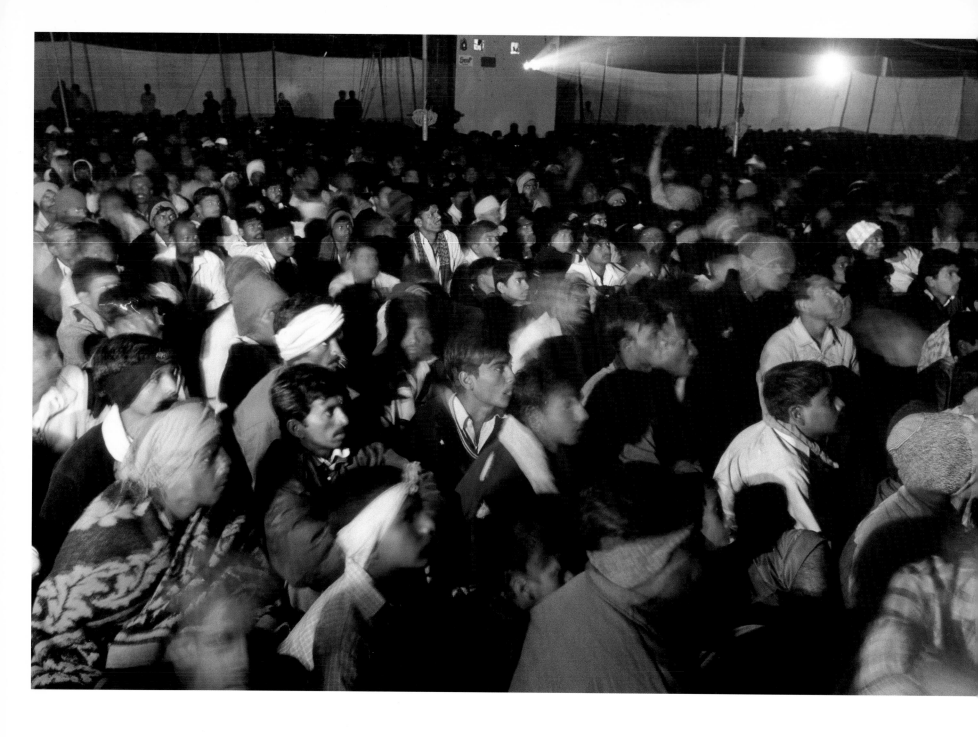

Villagers sit in clusters on the ground for the duration
of the three-hour film. Many have travelled from
neighbouring villages for the screening.

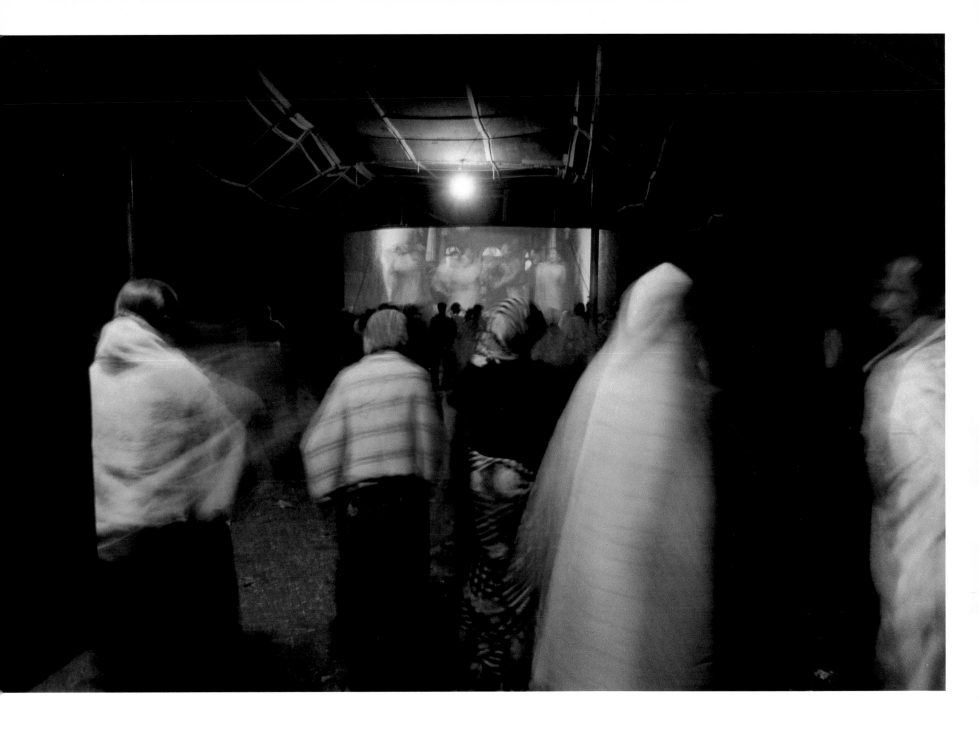

The end of a screening at around 3 a.m.

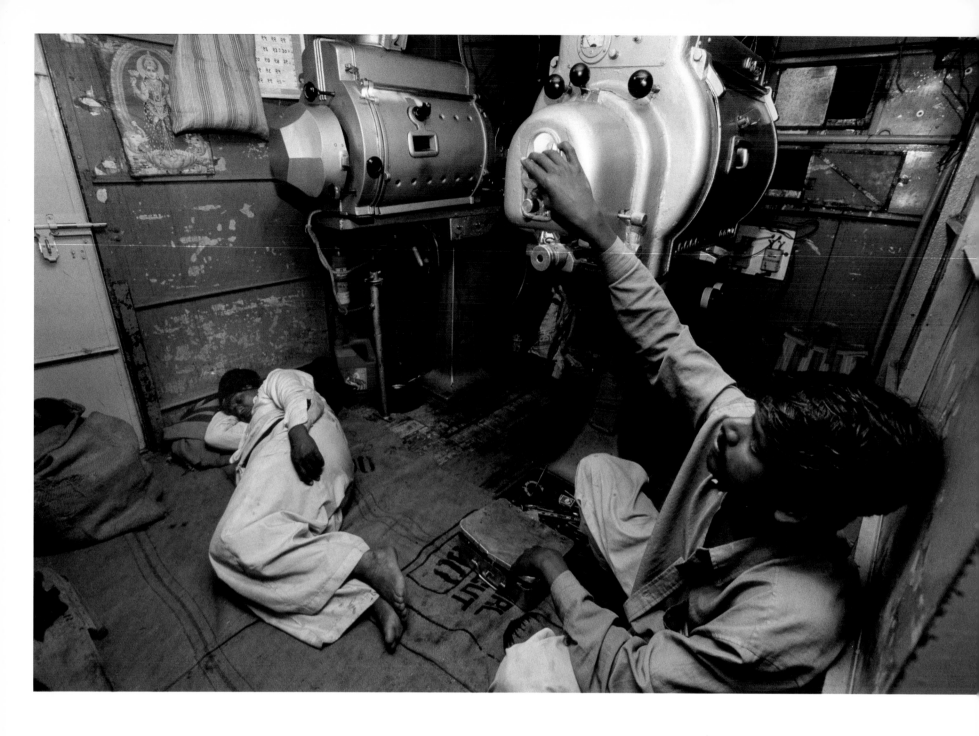

The films are shown late into the night and the
projectionists take turns sleeping between shows.
Right: The film is projected through a hole cut out
of the back of the touring cinema's truck.

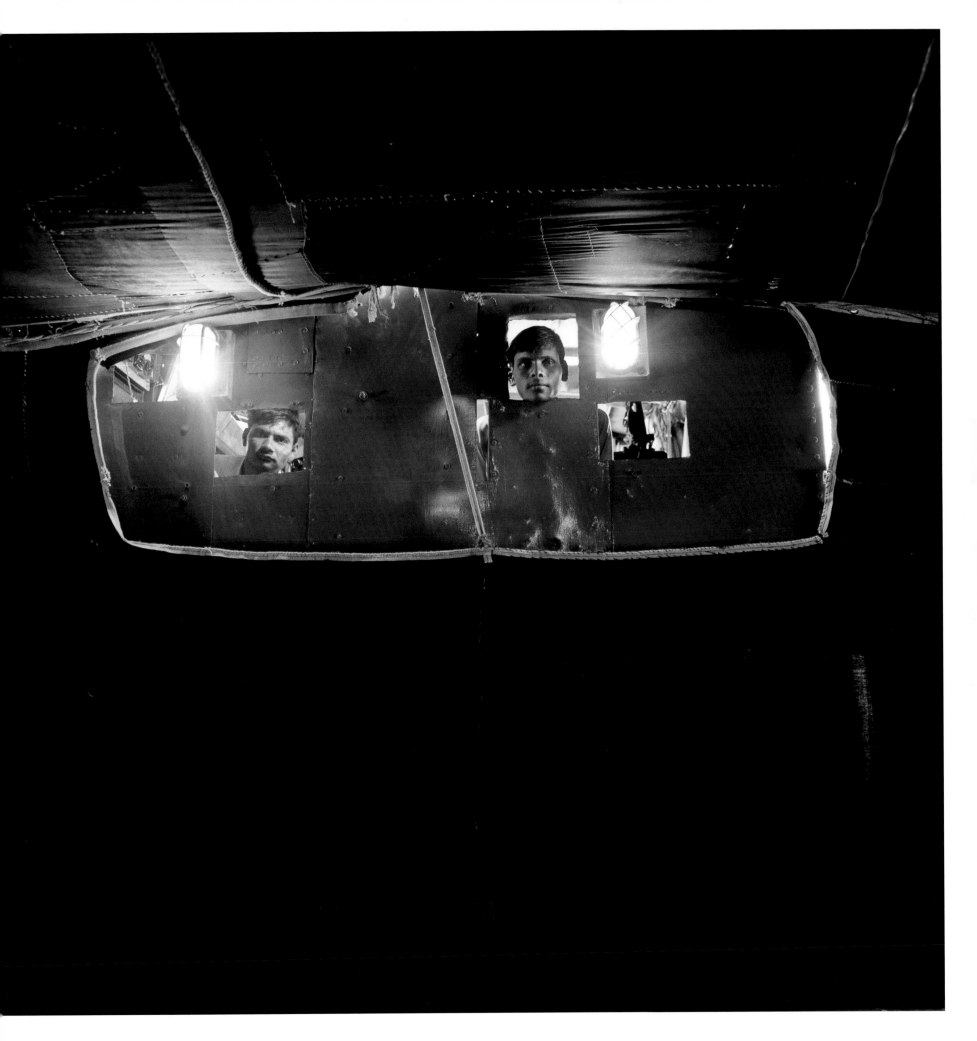

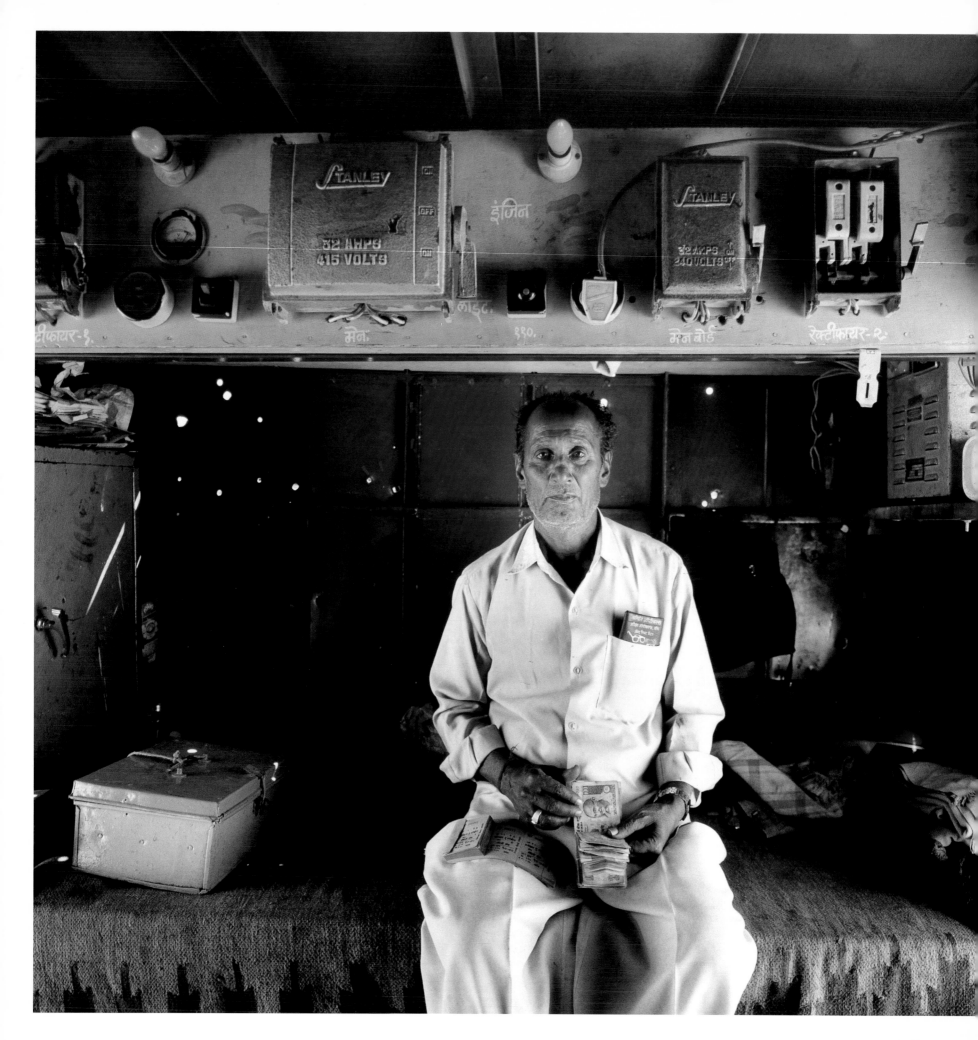

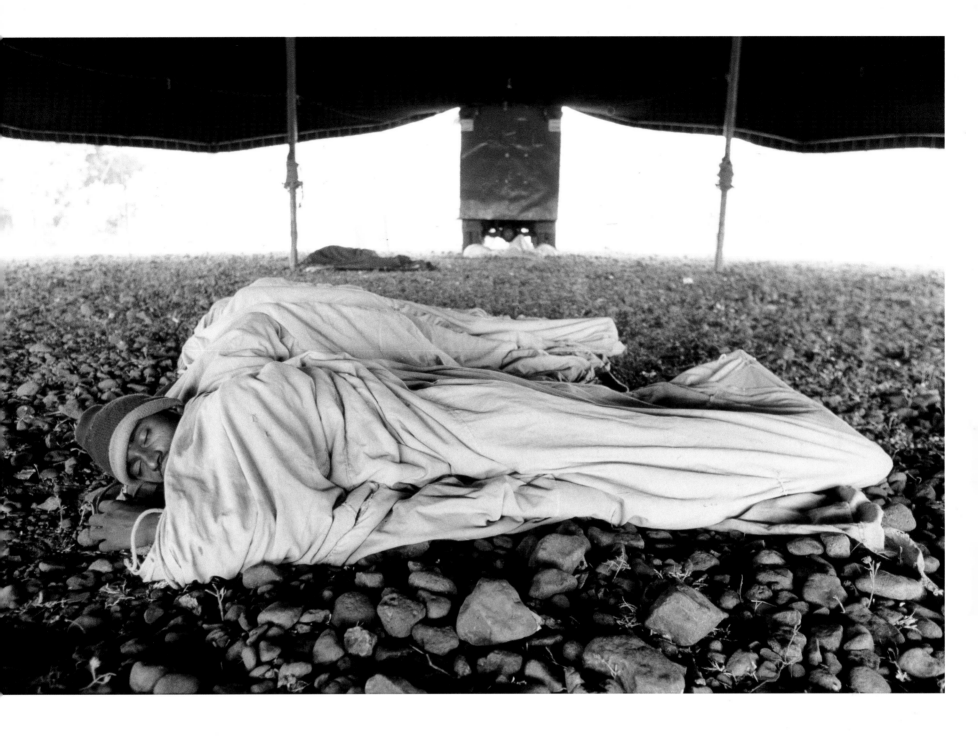

ft: One of the ticket sellers from the Amar Touring
nema counts the money from the matinee show.
he Indian government regulates ticket prices for
uring cinemas.

After a long night of showing back-to-back films to
villagers, crew members sleep either in the truck or in
the tent. They keep warm by wrapping themselves with
the tent's detachable canvas sides.

on the set

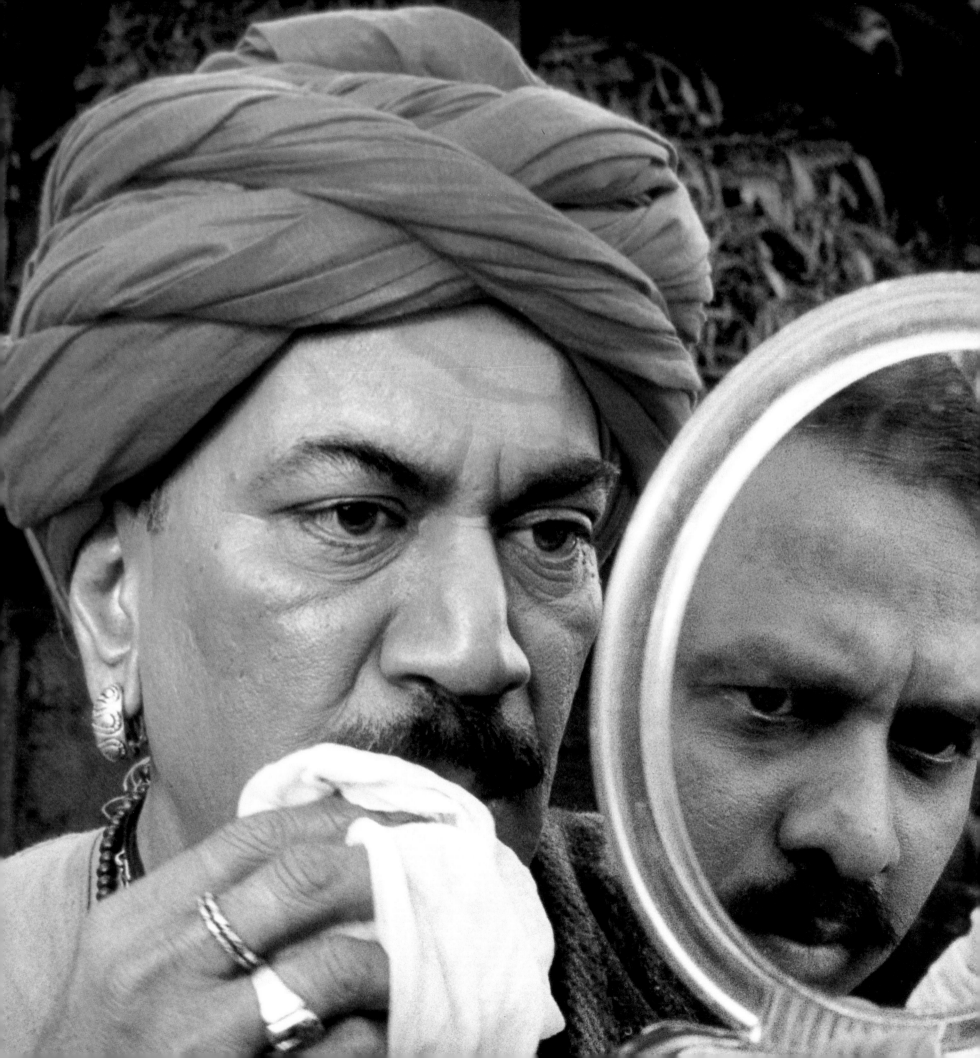

Stars Govinda and Sonali Bendre during a song-and-dance sequence on the set of *Jis Desh Mein Ganga Rehta Hai*. Locations are an important element of Hindi musical cinema. This was shot in Mahabaleshwar, a hill station in the state of Maharashtra. Songs are typically performed by the hero and heroine with dozens of dancers moving in unison behind them.

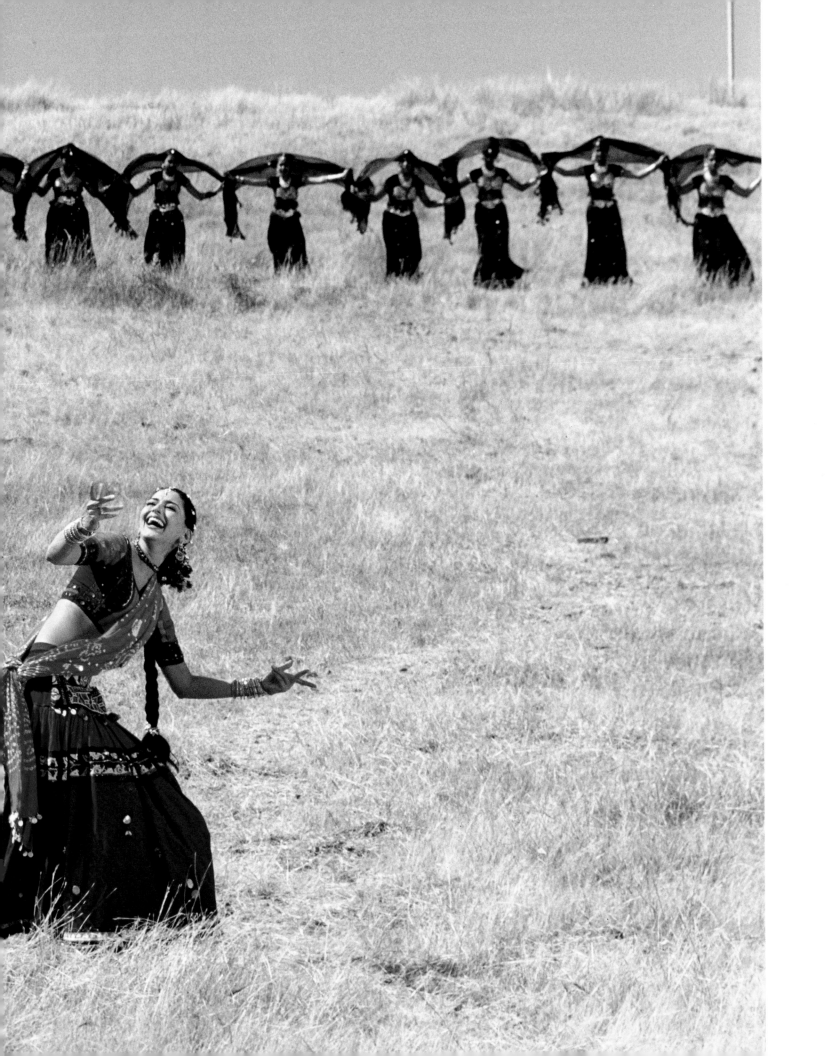

Following pages: These action scenes on the set of *Ab Ke Baras* take place at Film City in Mumbai, a large tract of land owned by the state that provides indoor and outdoor locations and post-production facilities. Action scenes are an important part of popular Indian cinema, and Indian films often end with long and elaborate fight sequences between hero and villain.

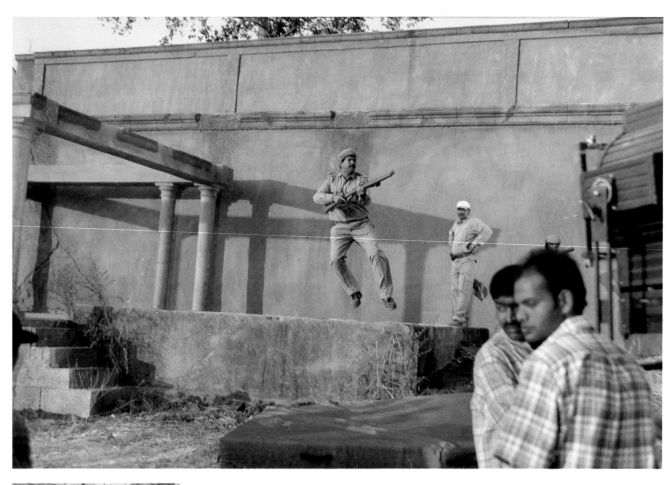
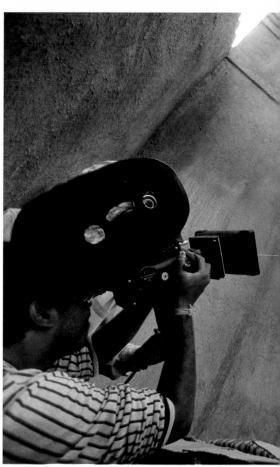
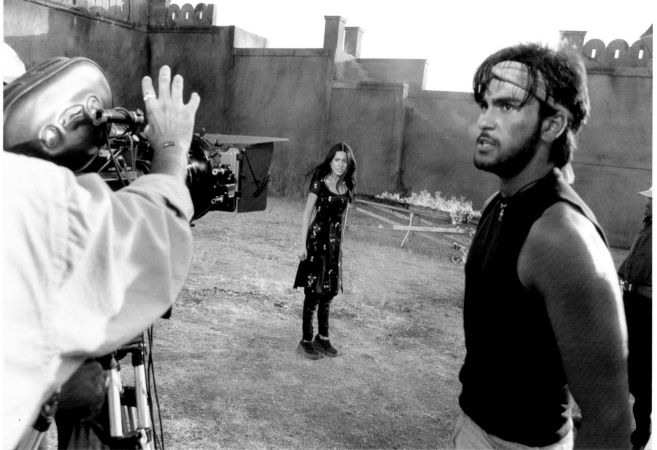
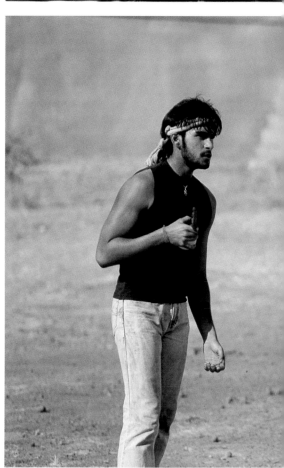

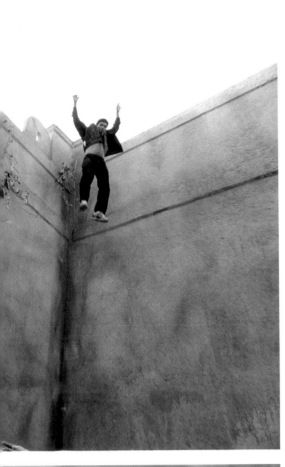

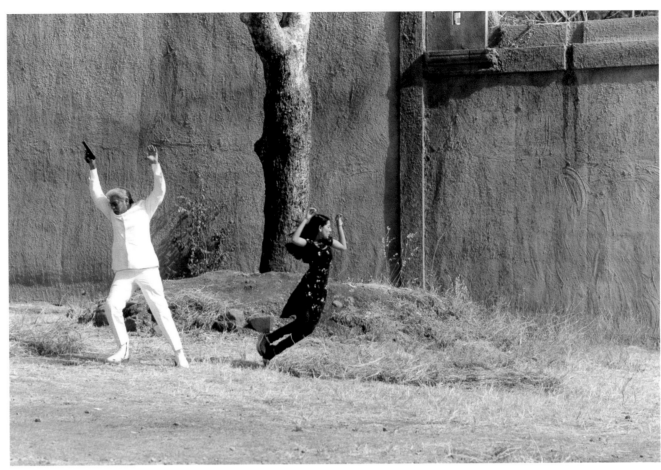

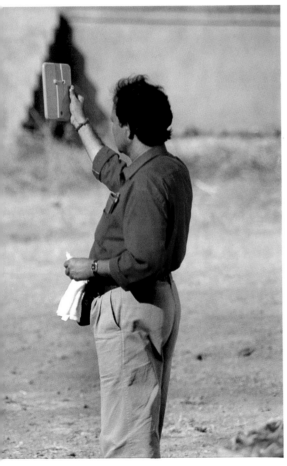

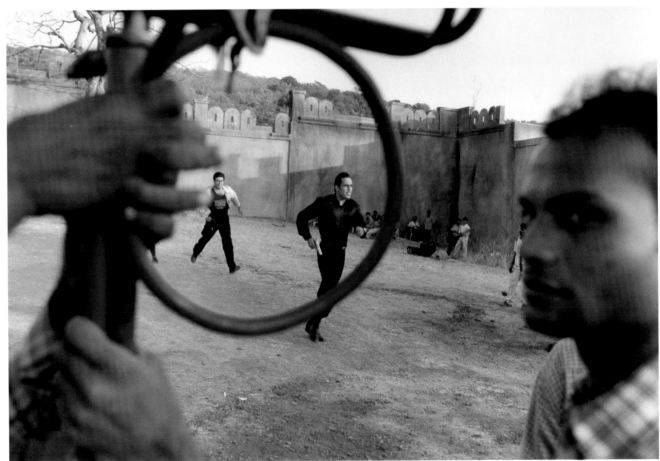

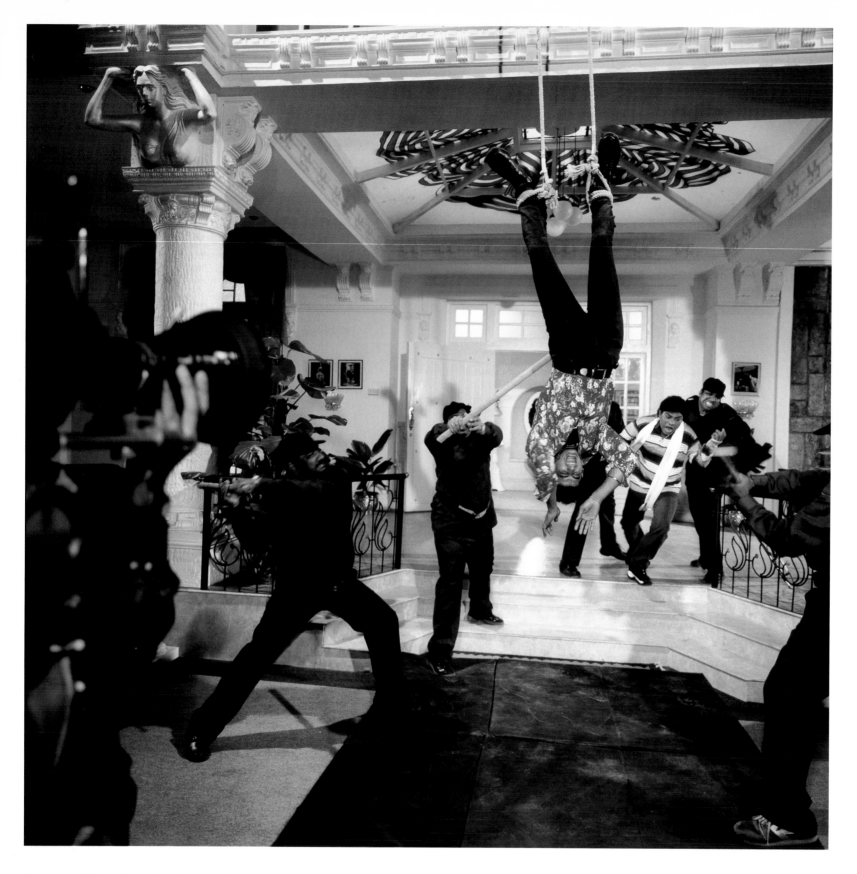

Stuntman Srikan Shetty dangles upside down during an action shot on the set of *Dil Ke Aas Paas*. This film was shot at Filmalaya Studios in north Mumbai where the Bollywood industry is centred.

Right: Leading actors Manoj Bajpai and Tabu during a love scene on a fantasy set at Mehboob Studios, Mumbai. Bollywood love scenes are often discreet, with little overt sexuality. Physicality and intimacy are usually woven into the film's song-and-dance numbers.

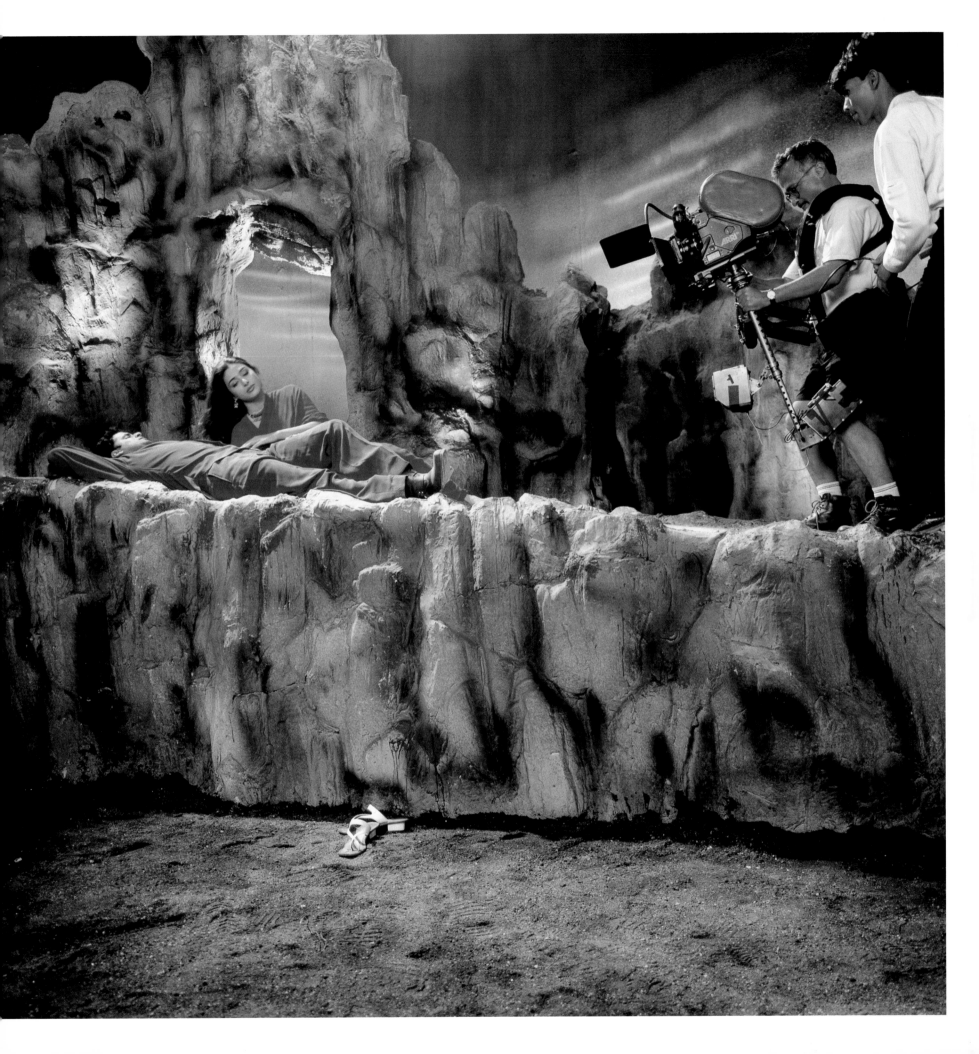

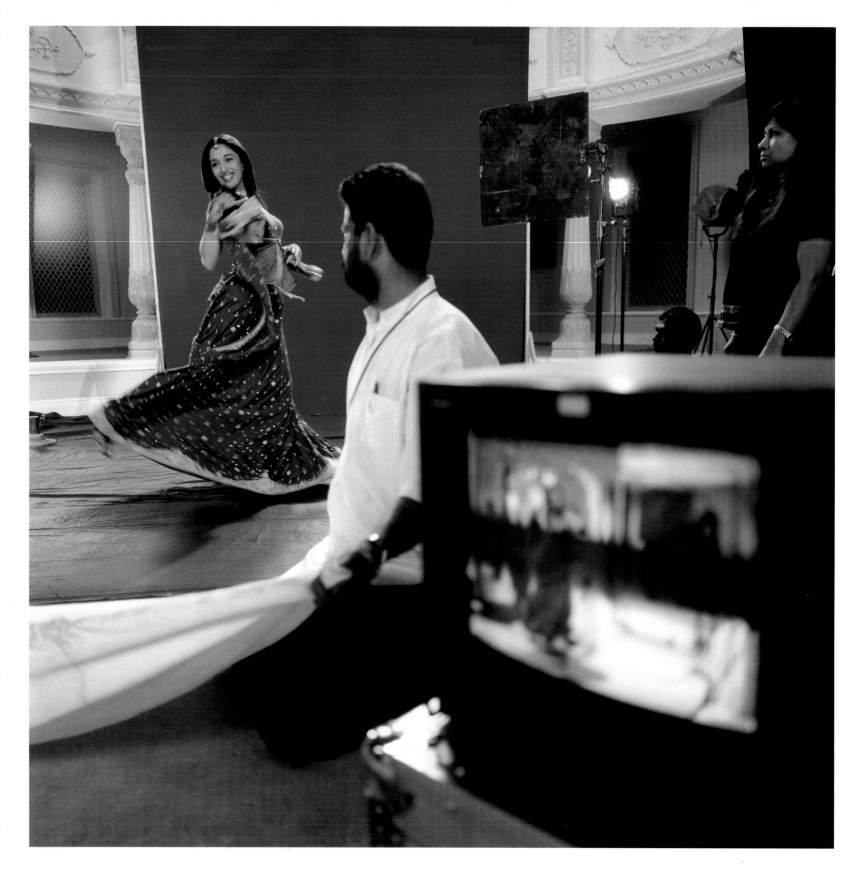

Above and right: Madhuri Dixit, the most popular star of the 1990s, at Filmistan Studios, Mumbai. Female stars have shorter film careers in Indian films than their male counterparts. By the time they are in their thirties, they are often regarded by the industry as too old to play the virgin heroines.

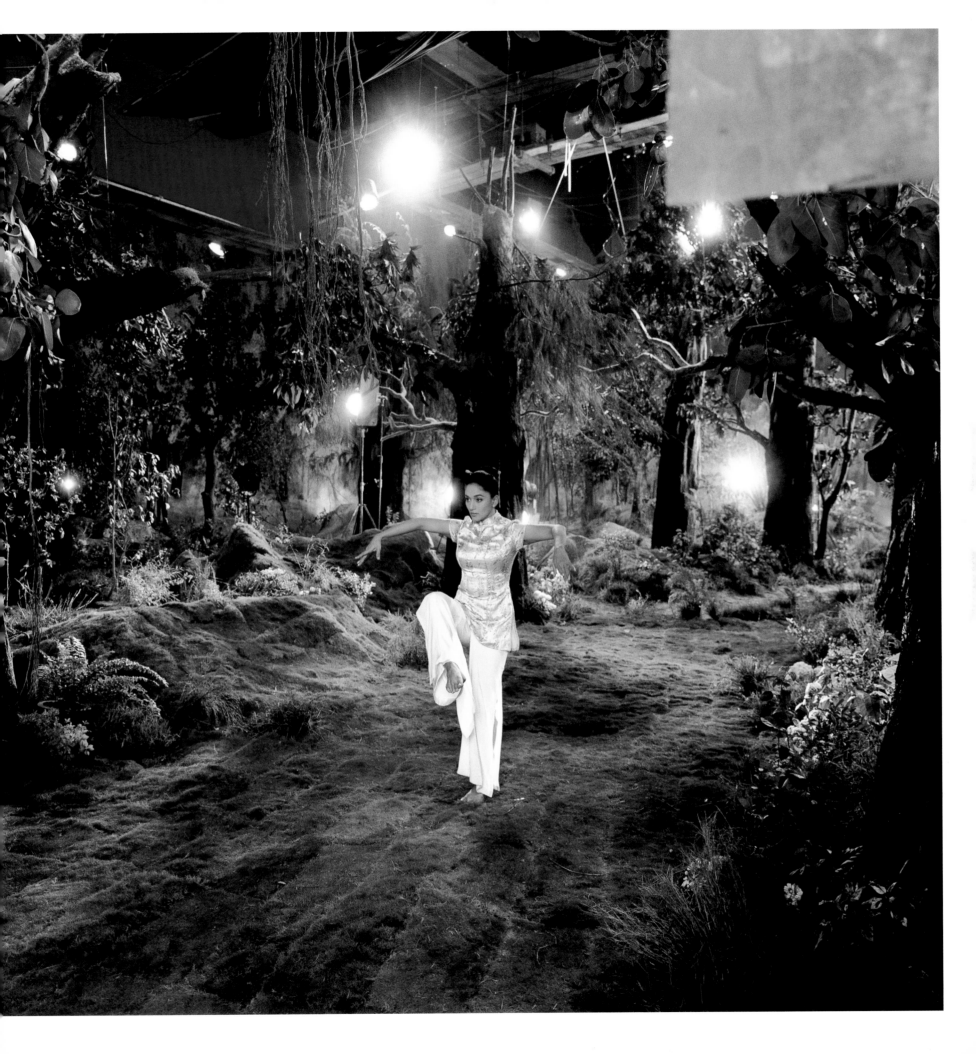

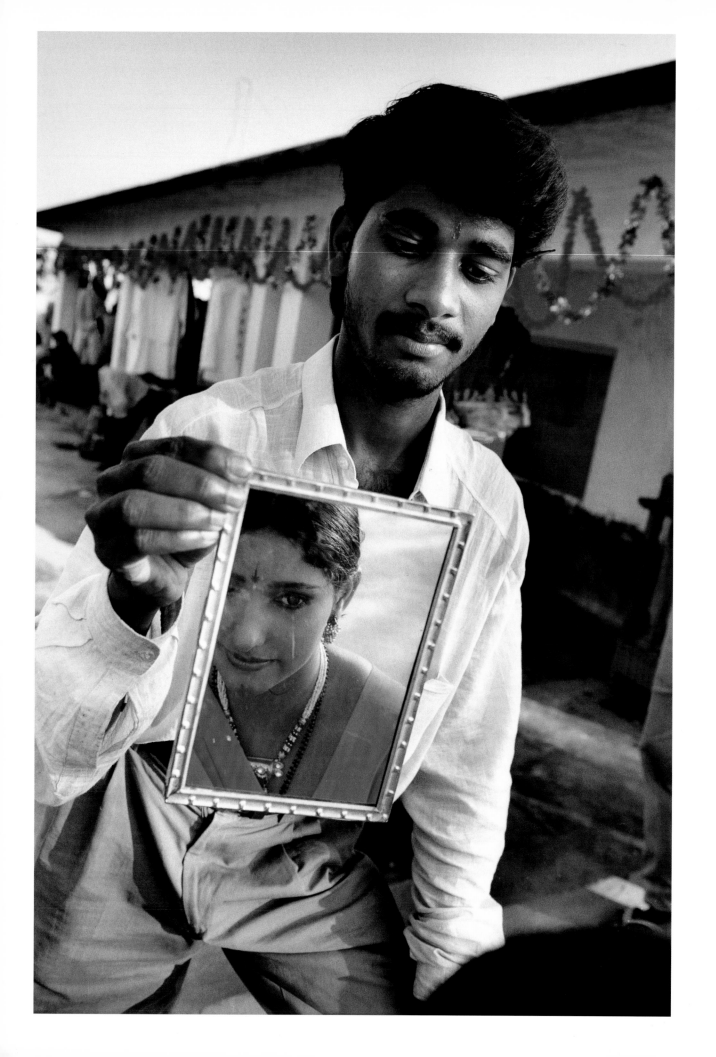

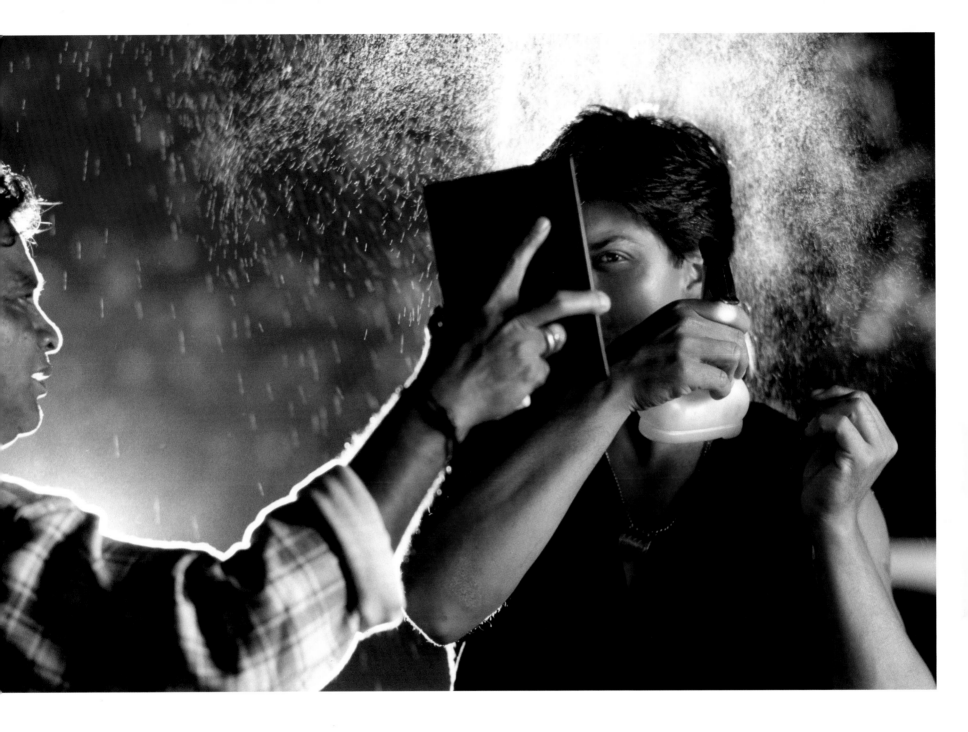

*: On the set of *Mere Sapnon Ki Rani*, Rajahmundry.
ve: Megastar Shahrukh Khan and his make-up
st prepare for the next scene at Film City in Mumbai.
ntial ingredients for a successful film are its stars,
sic, score, choreography and singers. A film featuring
an will most likely be a success, which explains his
a fee (up to the equivalent of US $1 million). His film
das, released in 2002 and shown worldwide, was the
st expensive Hindi film ever produced.

Actresses Madhoo and Urmila Matondkar embrace while a member of the film crew blocks the light from the camera with a black cloth. On the set of *Mere Sapnom Ki Rani*, Rajahmundry.

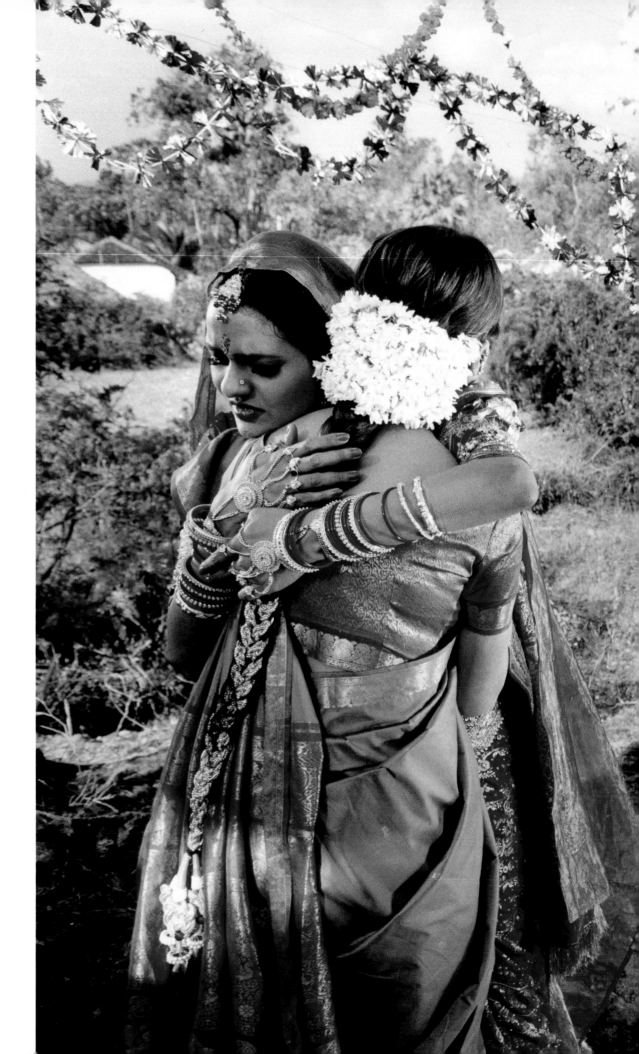

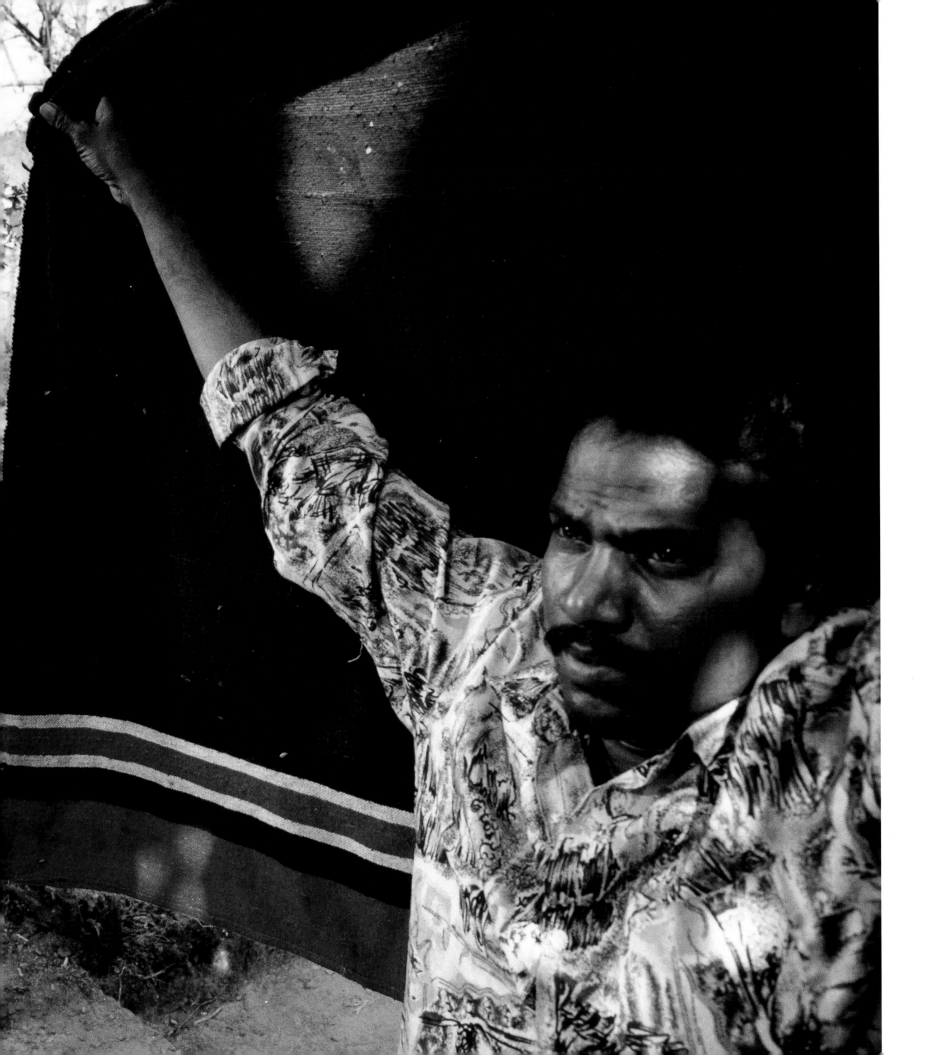

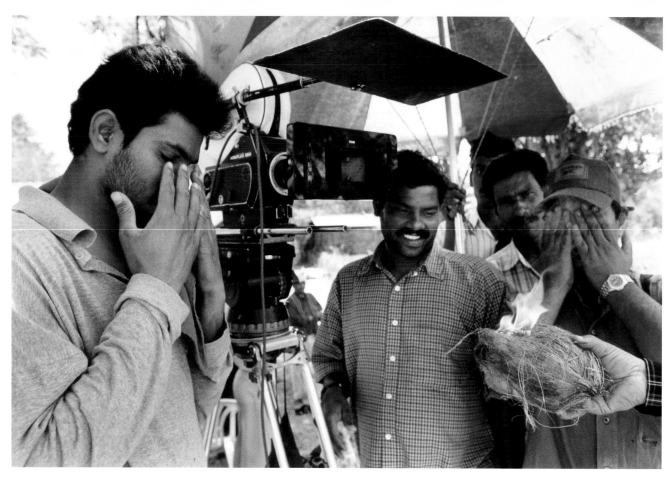

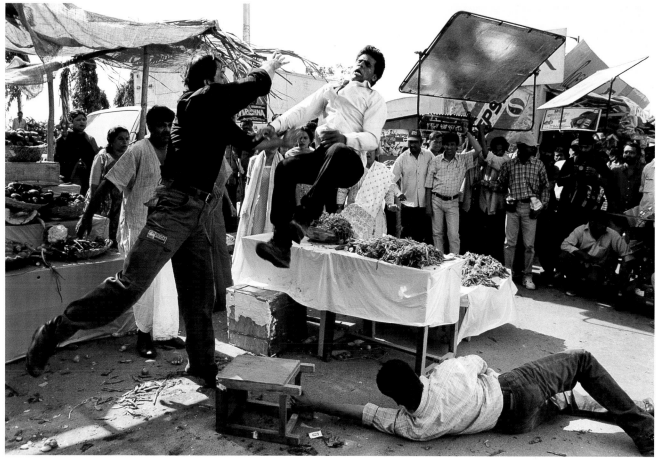

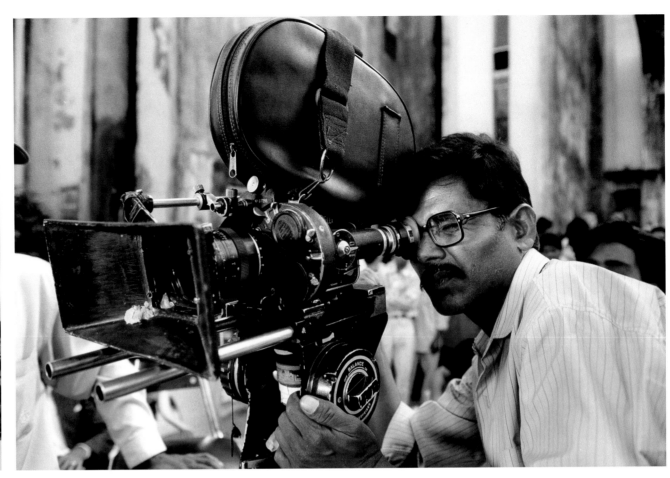

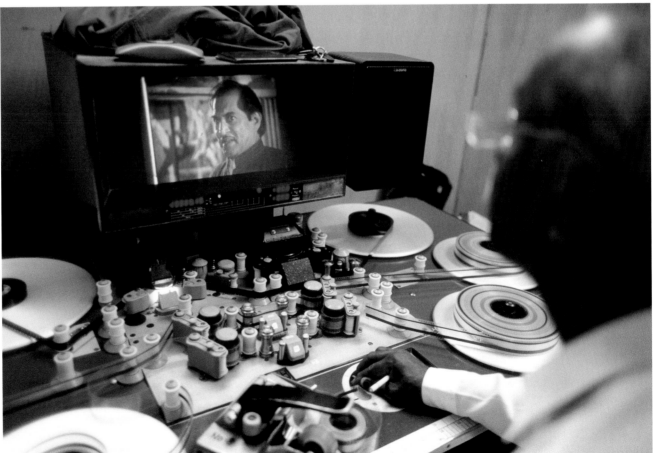

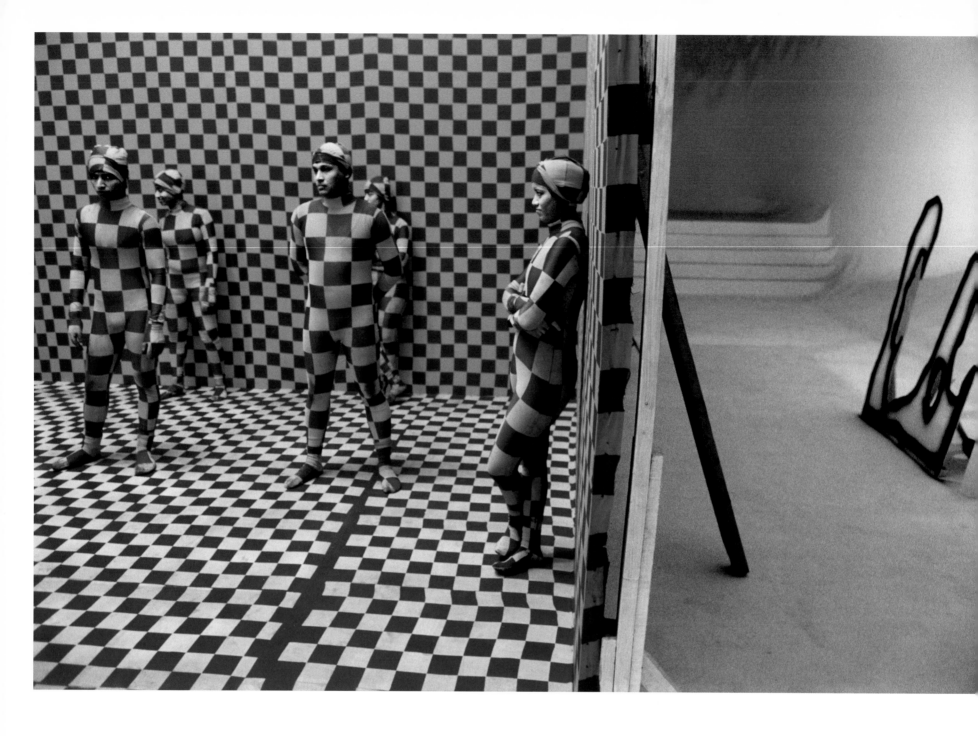

Previous pages, clockwise from top left: On many of the sets, the day begins with a prayer ('puja') and an offering where a coconut is cracked and drops of its water are sprayed onto the camera to pray for a successful day of filming. Improvisation is common practice in building sets, as seen here (top and bottom centre); a cameraman prepares for the shoot to begin; an editing suite in use; a stunt scene caught in mid-action.

Above: Dancers prepare for a song-and-dance sequence on the set of *Hum To Mohabbat Karega* at Raj Kamal Studios in Mumbai.

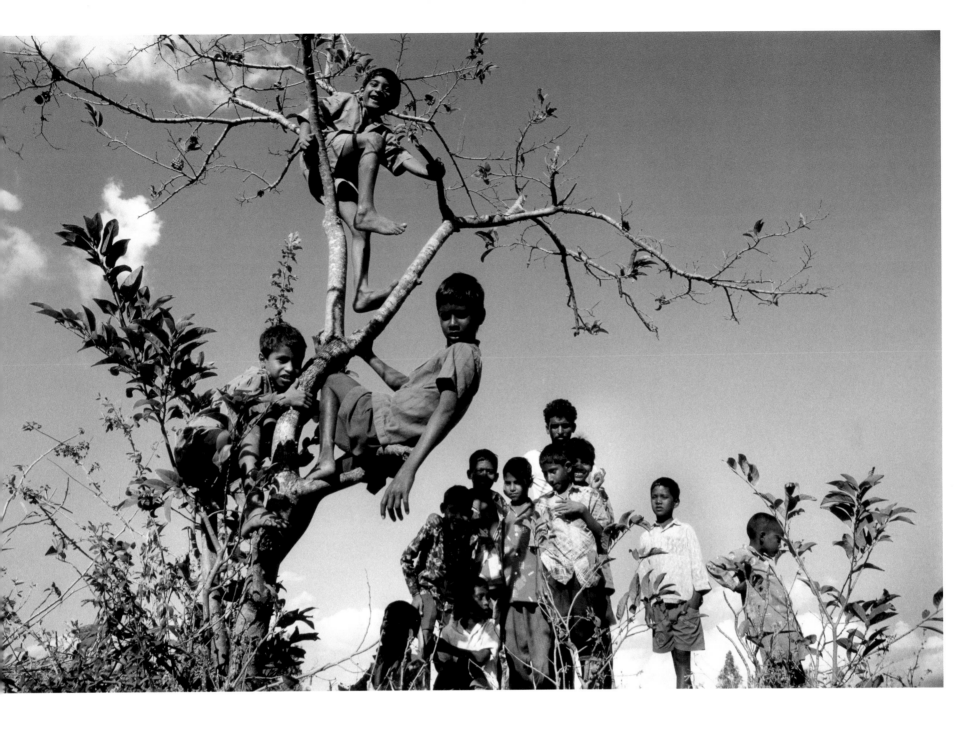

Children from nearby villages gather to watch the filming of *Mere Sapnon Ki Rani* in a small village near Rajahmundry. The children climb trees to get the best possible view of the film stars.

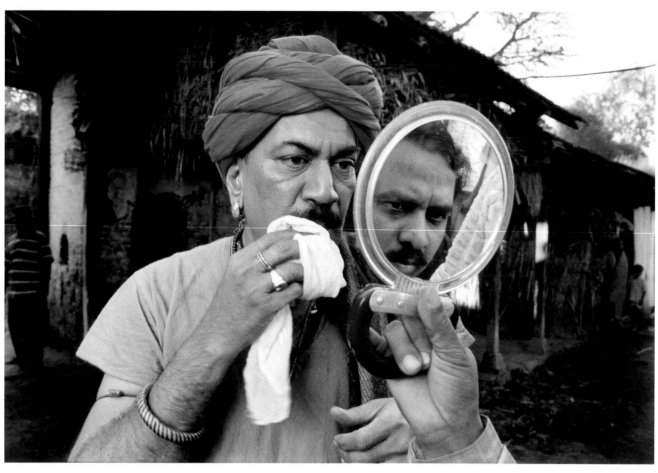
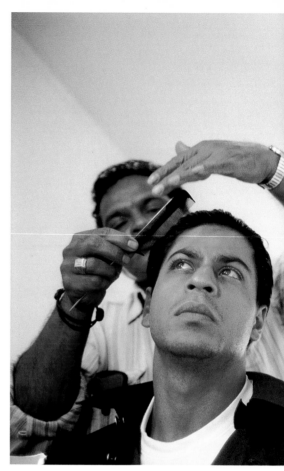
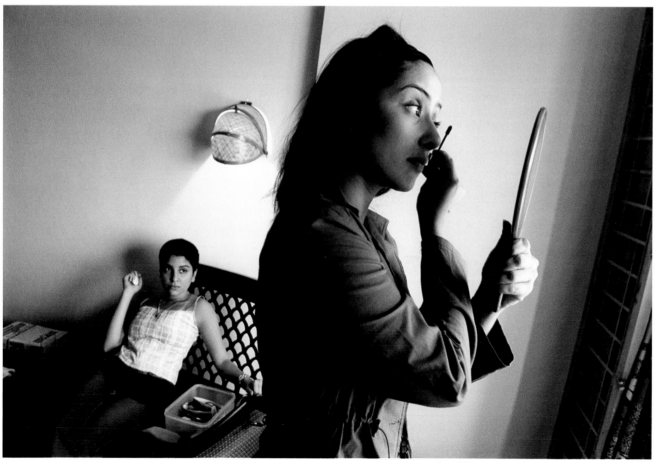
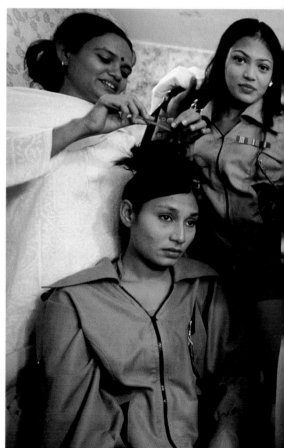

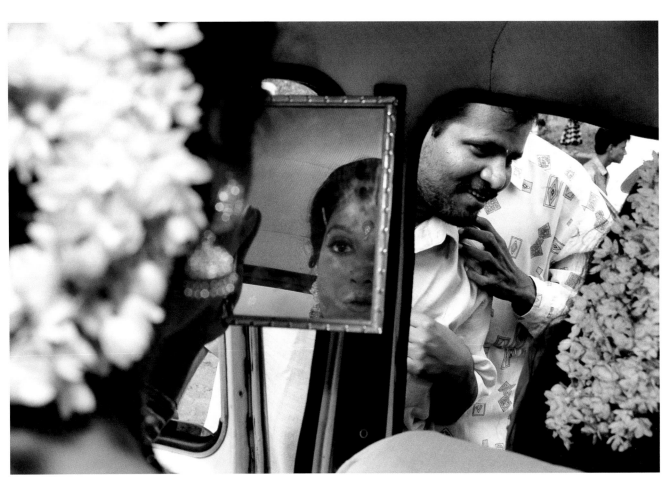

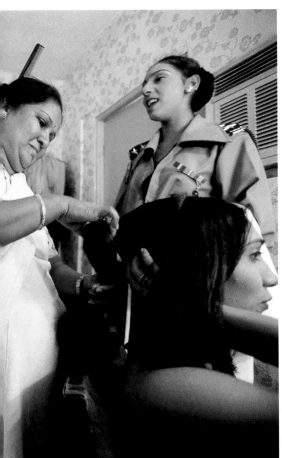

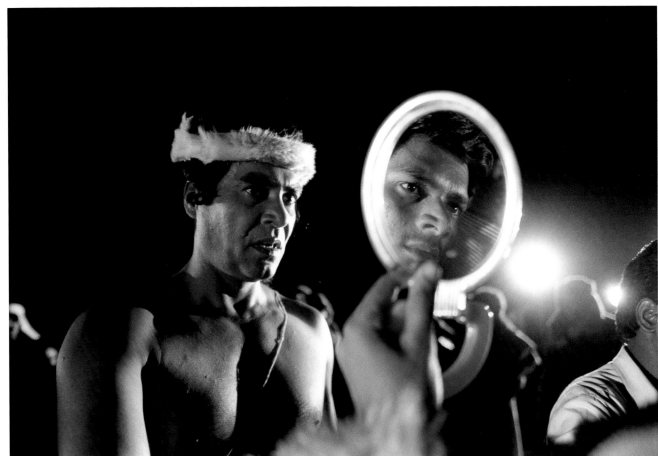

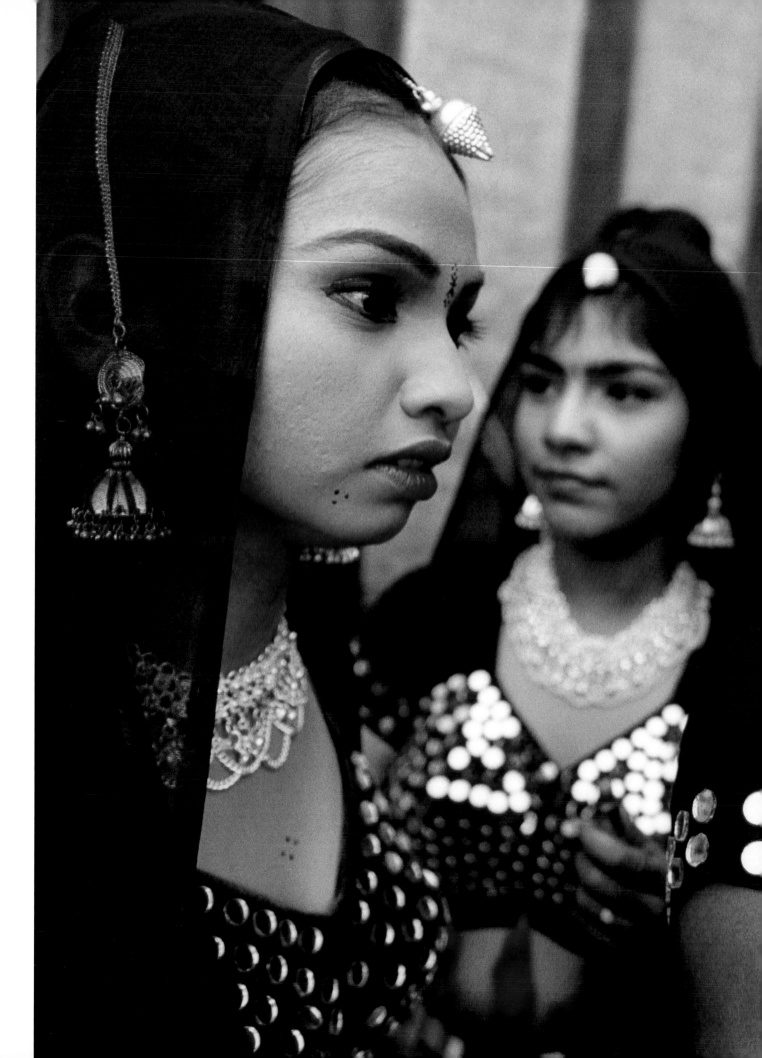

Previous pages, clockwise from top left: Character actors and stars (Shahrukh Khan, centre top, and Manisha Koirala, bottom left) receive last-minute touch-ups from their make-up artists before filming begins; dancers from *Chor Machai Shor* (bottom centre) prepare for a song-and-dance sequence.

Dancers prepare for a song-and-dance sequence on the set of *Jis Desh Mein Ganga Rehta Hai* in Panjgani, Maharashtra. Song-and-dance routines are one of the most important components in Indian films.

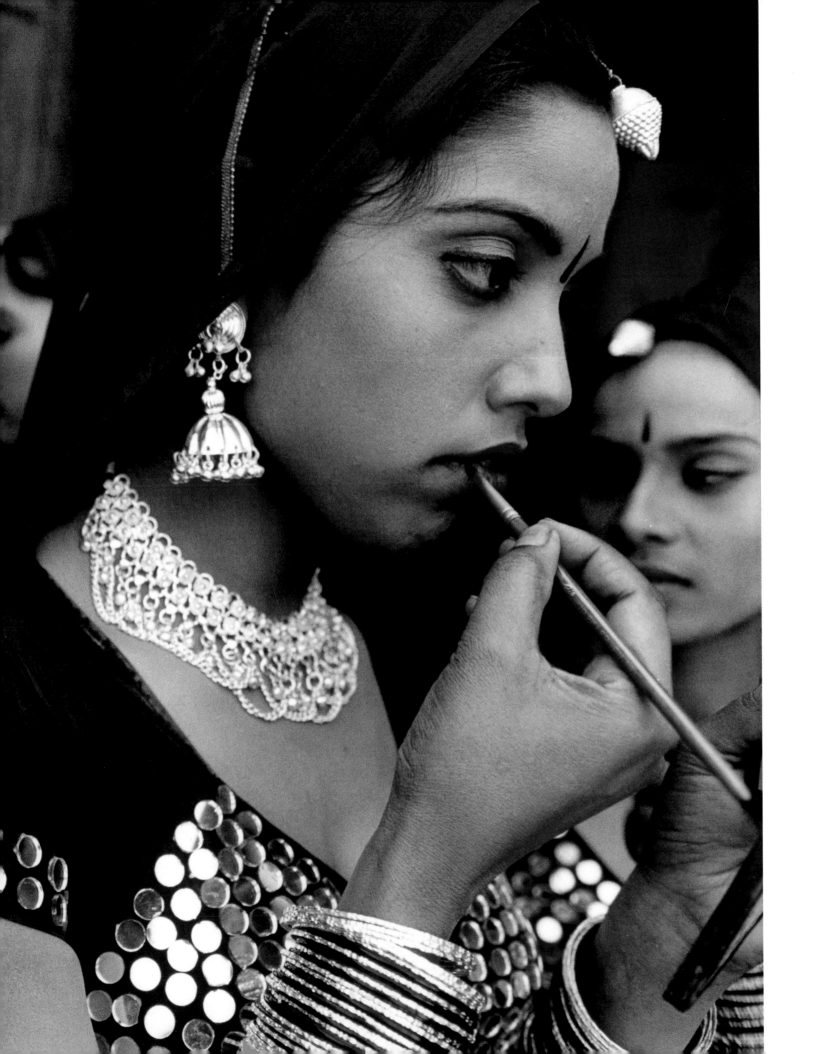

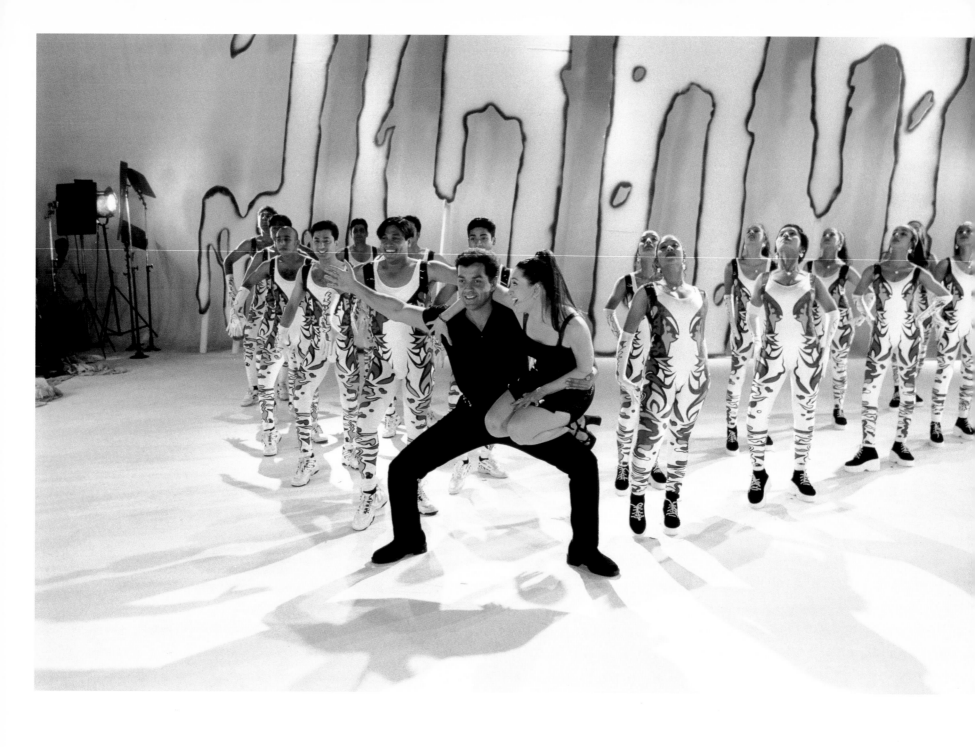

Actors Bobby Deol and Karishma Kapoor work through
elaborate dance steps. Both stars come from families
of actors. Bobby Deol's father, Dharmendra, enjoyed
enormous fame in the 1970s as an actor and director.
Karishma's grandfather, Raj Kapoor, had a huge
following in Russia, China and the Middle East
and was one of India's first international stars.

Right: A lovesong-and-dance sequence starring Bobby
Deol and Bipasha Basu on the set of *Chor Machai Shor*
at Mumbai's Filmalaya Studios. Bollywood films tend to b
spectacular melodramas about love and romance. Kissir
scenes are allowed in the movies but explicit eroticism i
strictly regulated by the country's censorship laws.

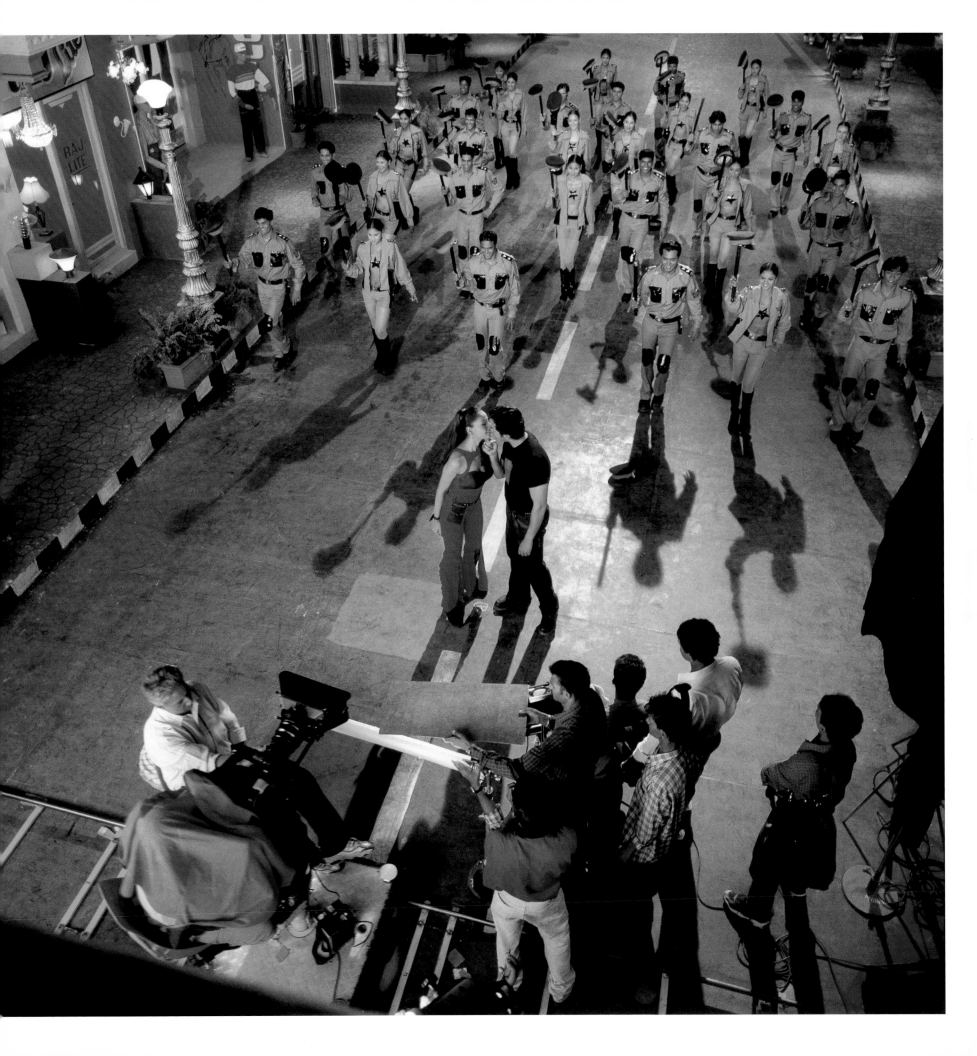

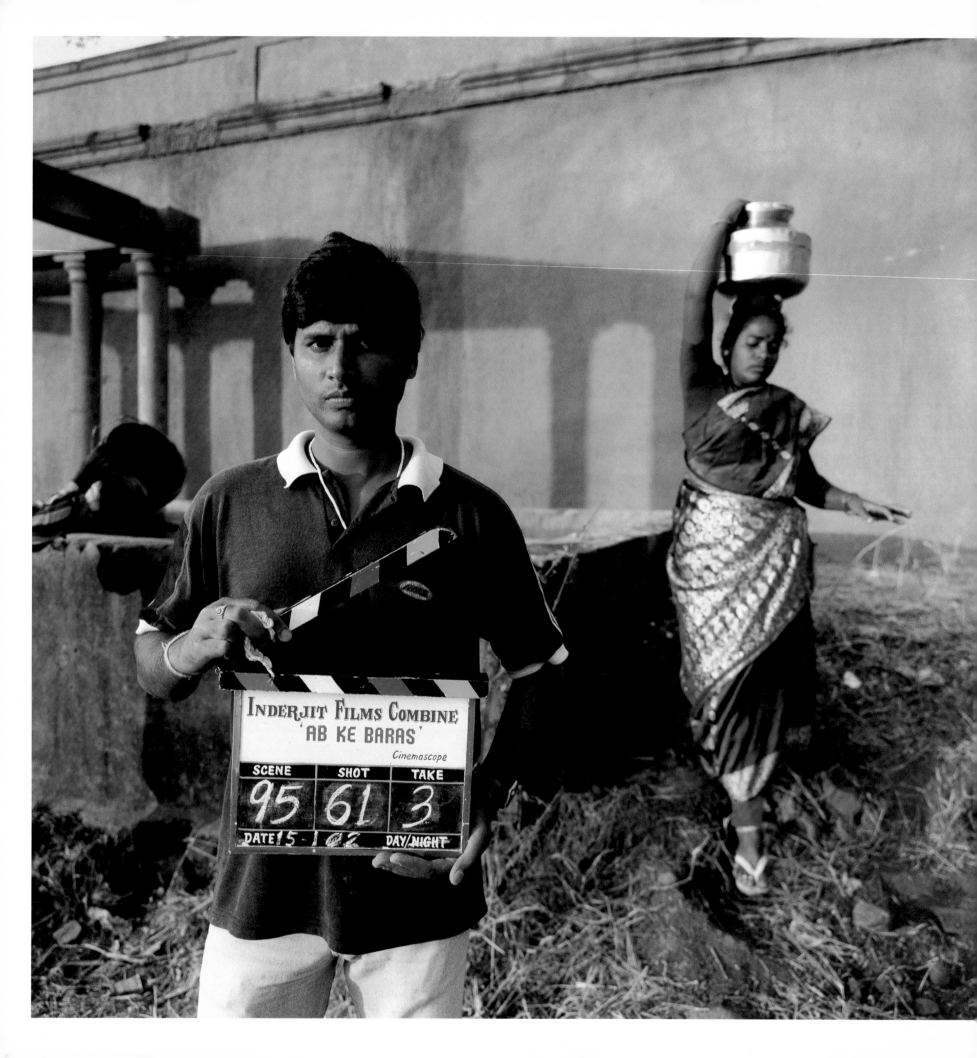

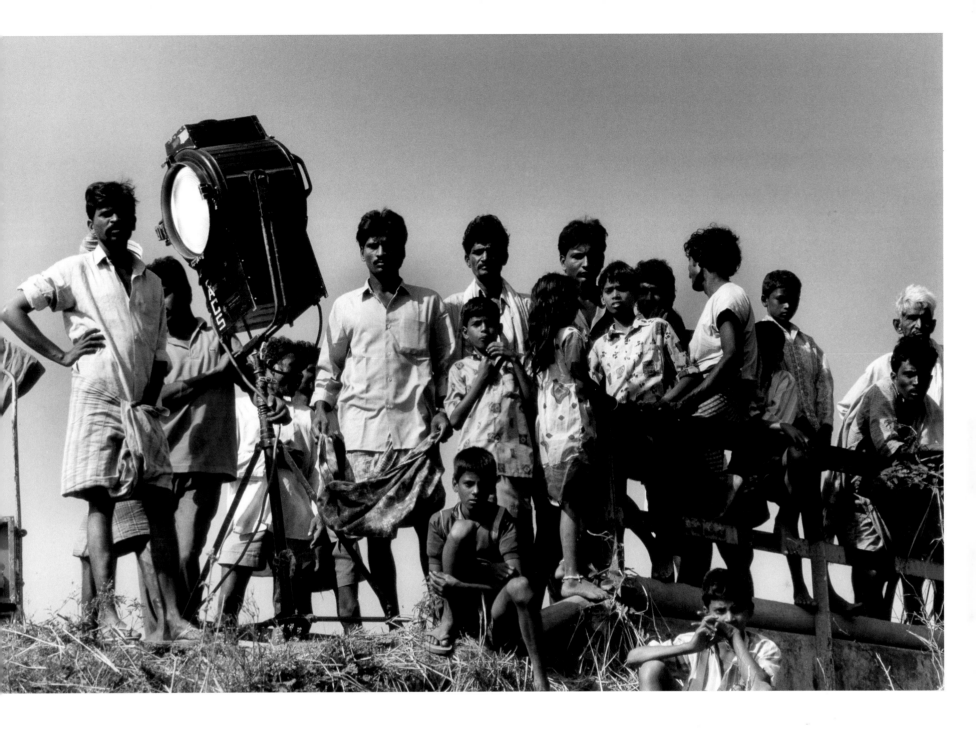

ft: On the set of *Ab Ke Baras* at Film City, Mumbai.
oove: Villagers gather to watch the filming of *Mere*
pnon Ki Rani in a small village near Rajahmundry.

the characters

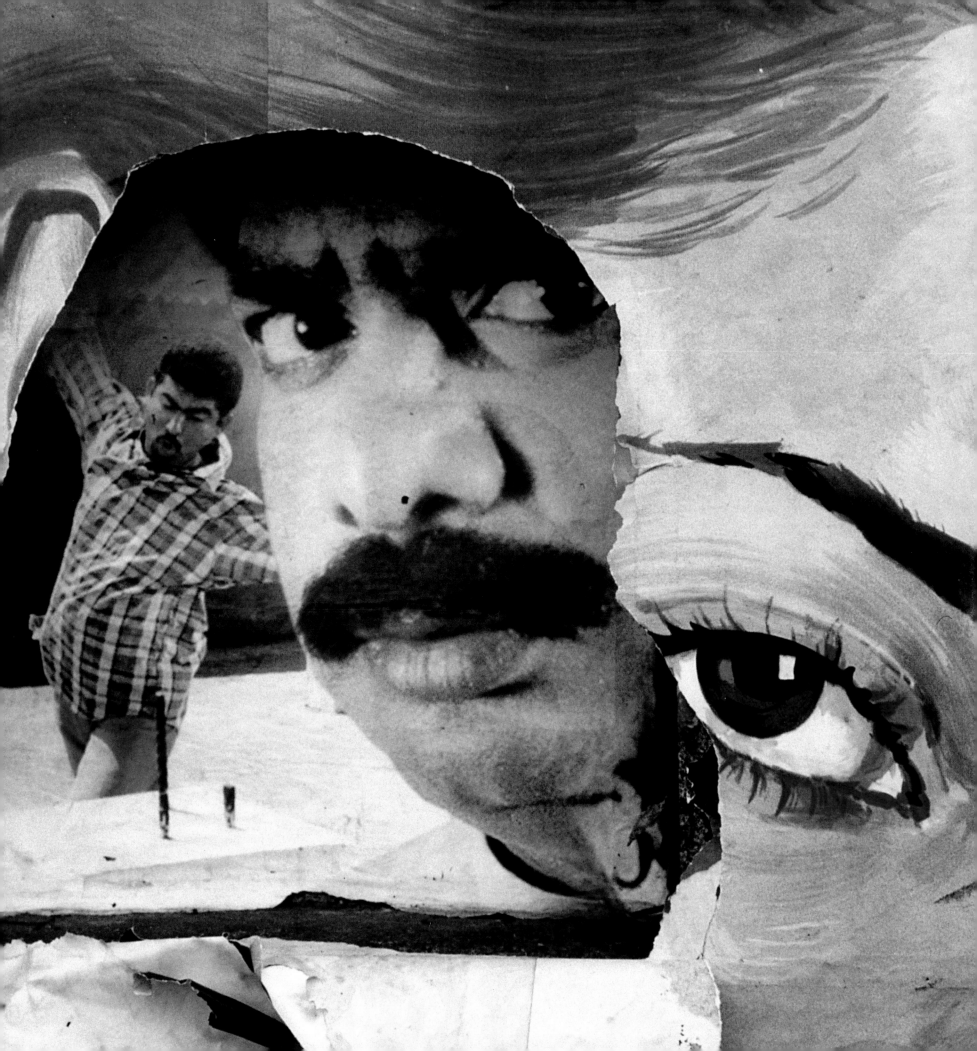

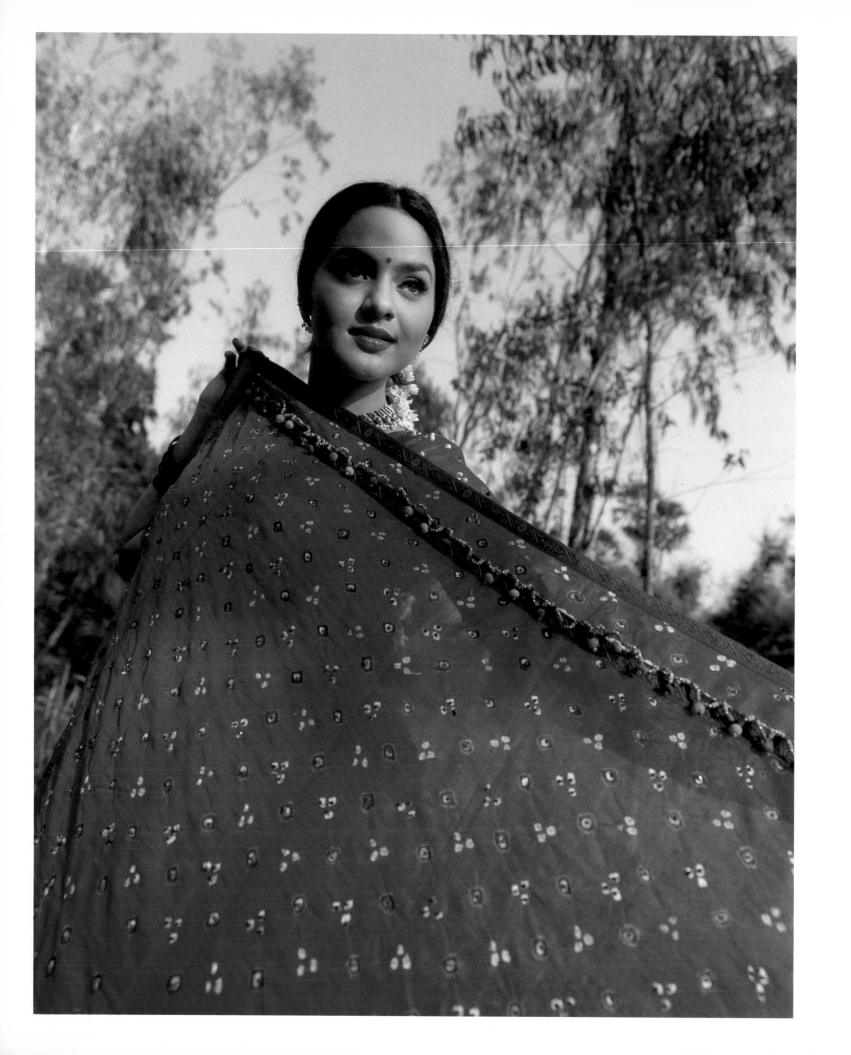

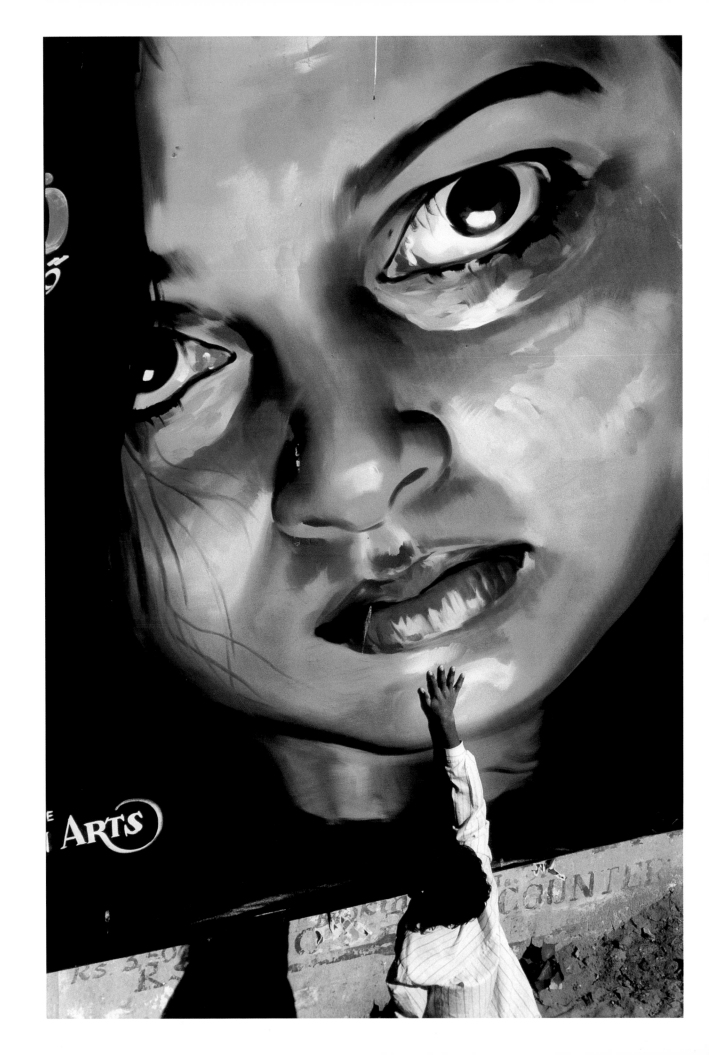

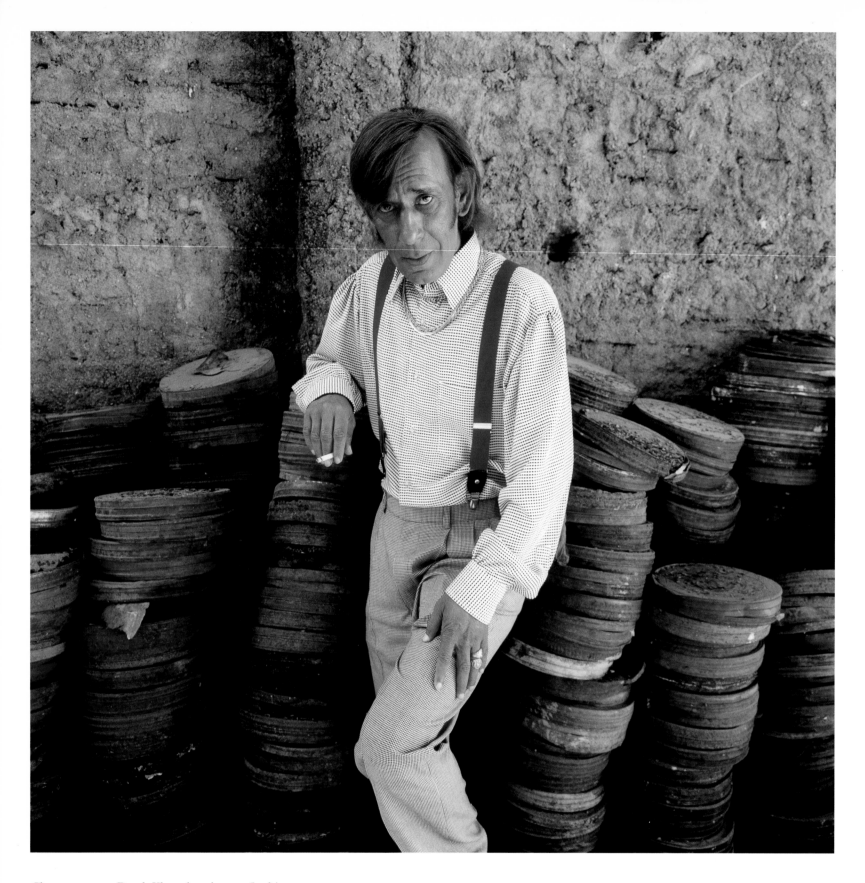

Character actor Razak Khan, best known for his gangster sidekick roles, on the set of *Dil Ke Aas Paas* in Filmalaya Studios, Mumbai.

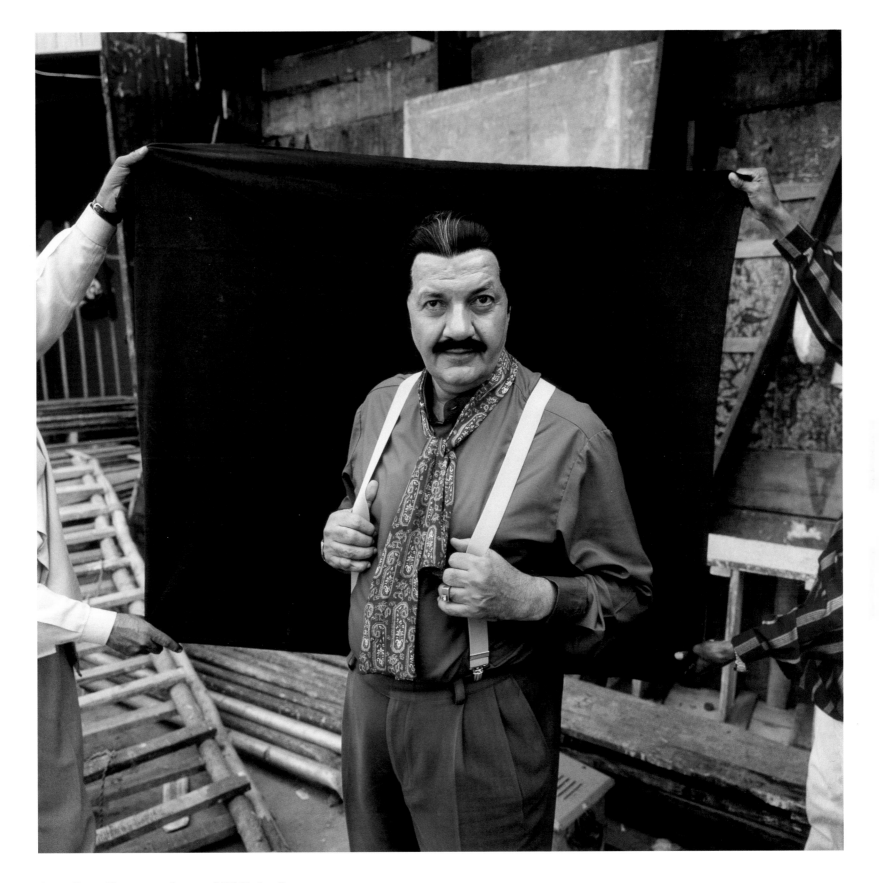

Actor Prem Chopra on the set of *Dil Ke Aas Paas* at
Filmalaya Studios, Mumbai. Chopra has played a villain
for most of his thirty-seven years in film and is one of the
most famous villains in Hindi cinema. 'When I was a kid,
just mentioning Mr Chopra's name made me scared,'
says action-scene director Mahendra Verma.

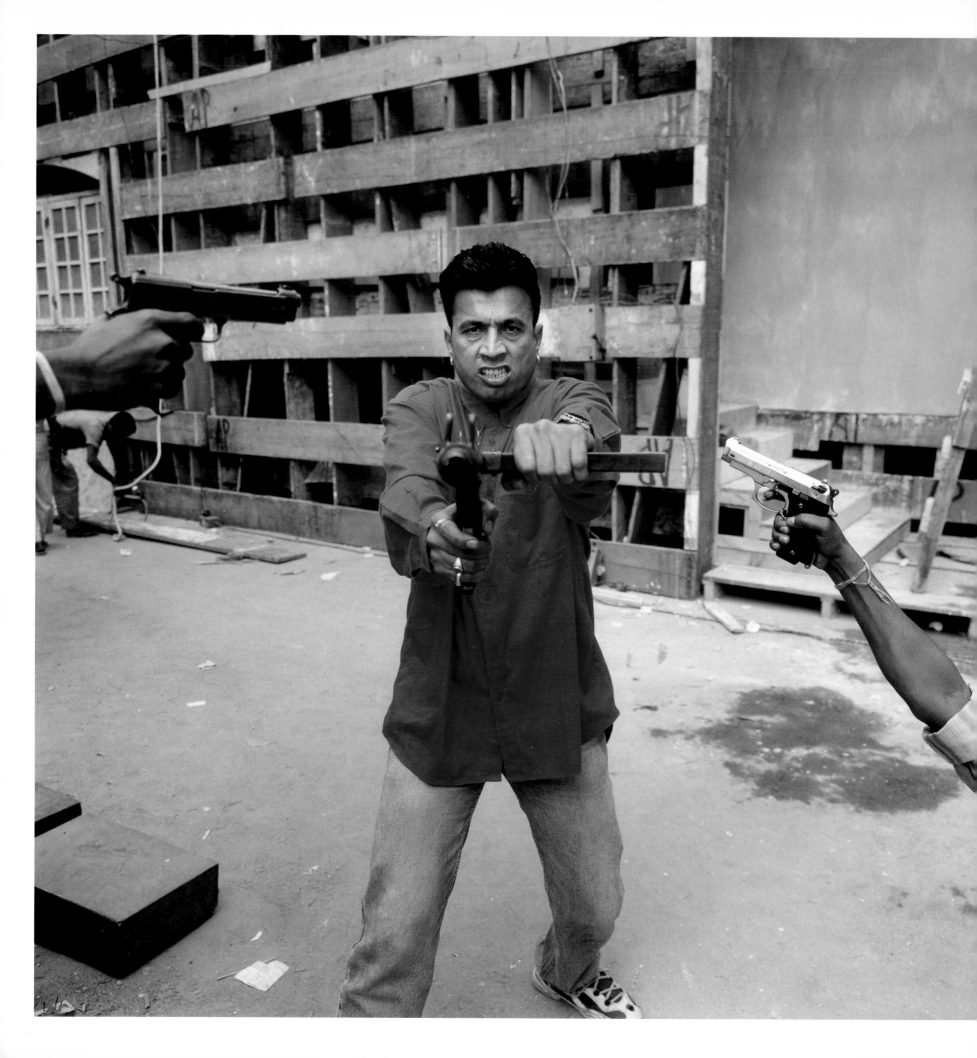

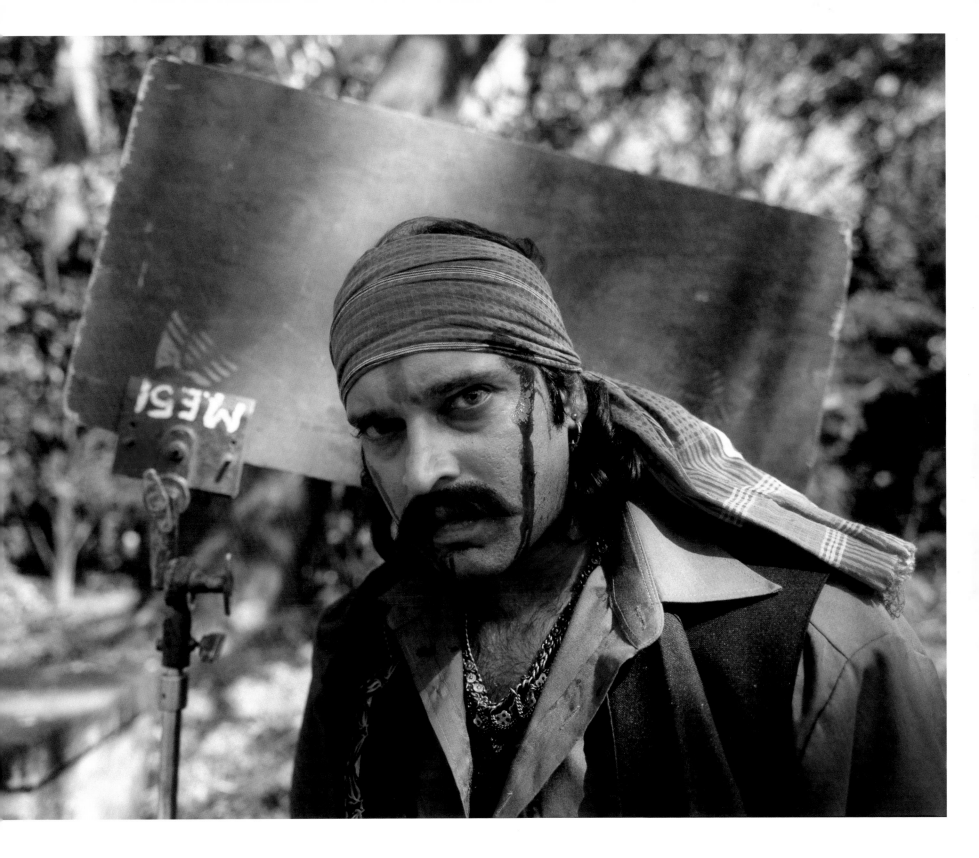

Left: On the set of *Dil Ke Aas Paas* at Filmalaya Studios, Mumbai with action-scene director and stunt-master Mahendra Verma. Verma is one of five brothers who, together with their father, are all action-scene directors and stuntmen. *Above:* A character actor playing a villain, Studio No. 12 in Film City, Mumbai.

Artists at Mohan Arts Studio in Chennai take a break in front of the hand-painted cut-outs they are working on. The cut-outs, which can be as high as 18 metres, will be placed outside cinemas in Chennai. These larger-than-life advertisements typically cost less to hand-paint than to print. In southern India, particularly in Chennai and Hyderabad, hand-painted film advertisements like these still outnumber printed ones.

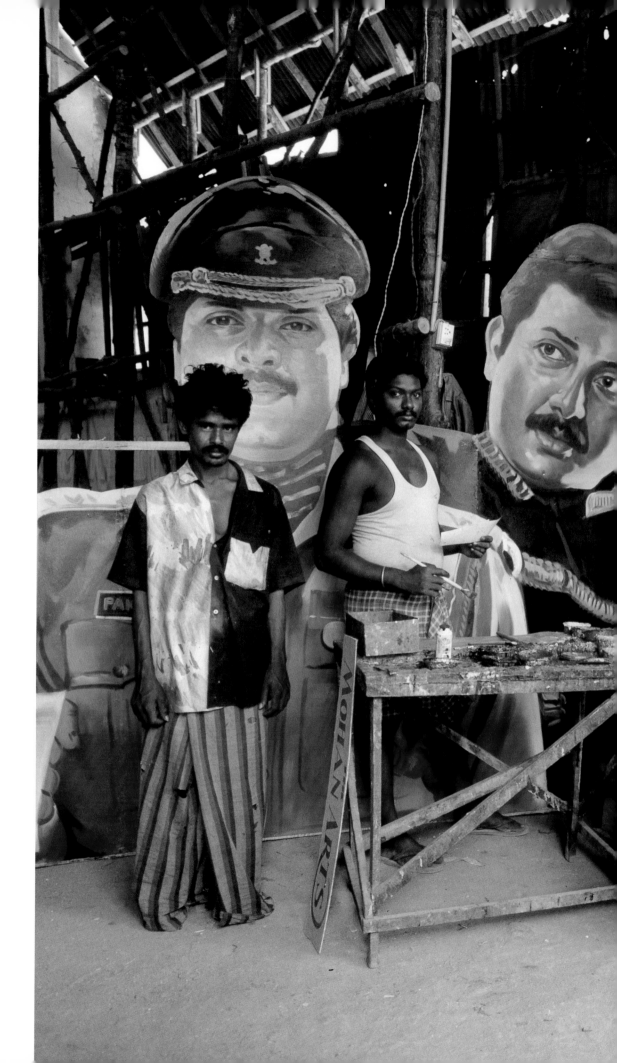

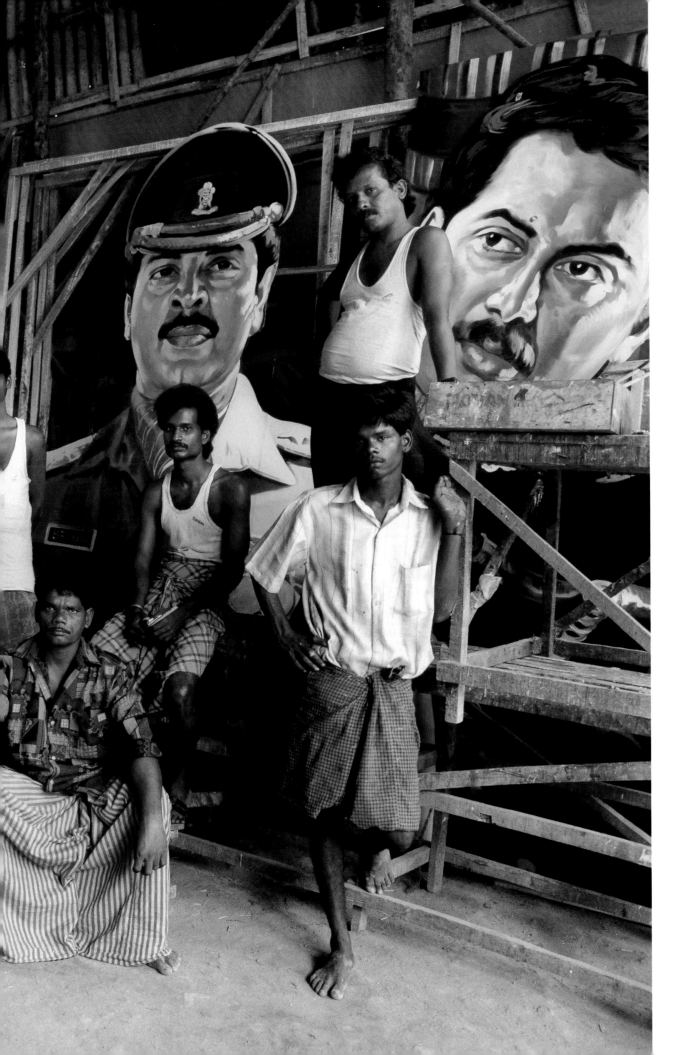

Following pages: Giant film cut-outs and advertising billboards dominate the streets of large cities in India. In Chennai, hand-painted cut-outs are placed near the cinemas, and on the main commercial roads (left and centre). In Mumbai, hand-painted banners have been almost entirely replaced by printed ones (right).

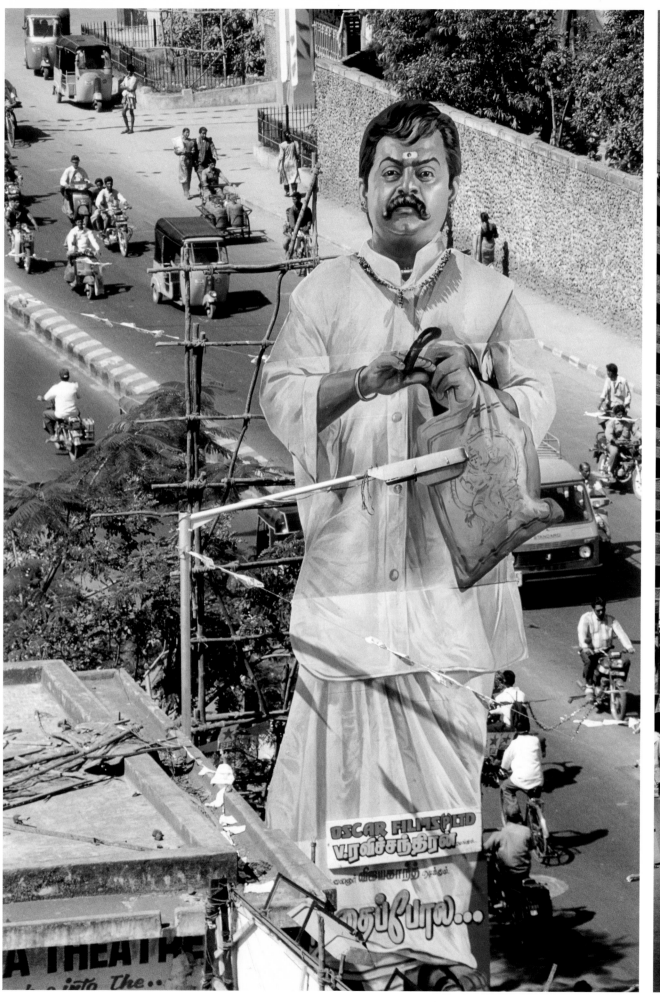
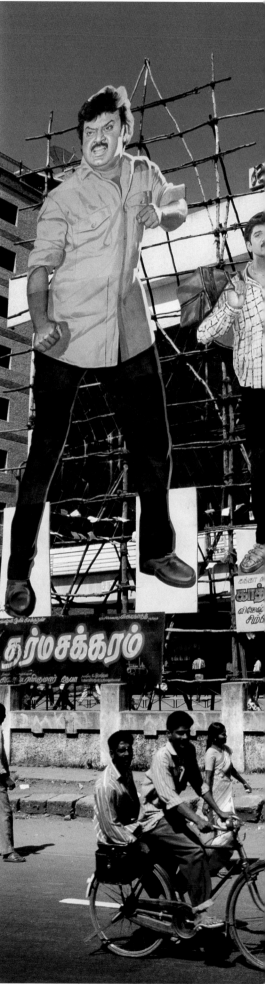

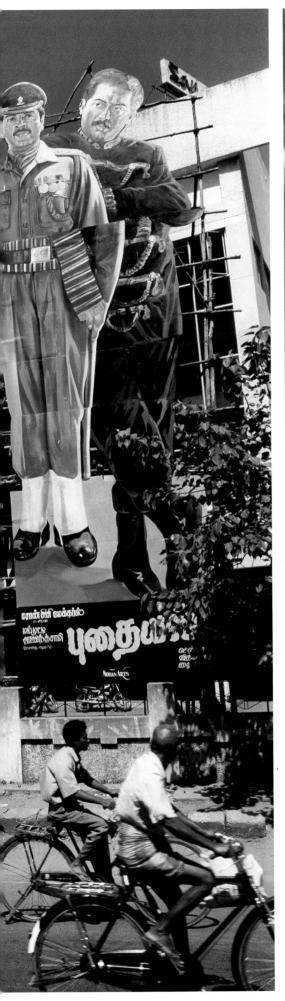
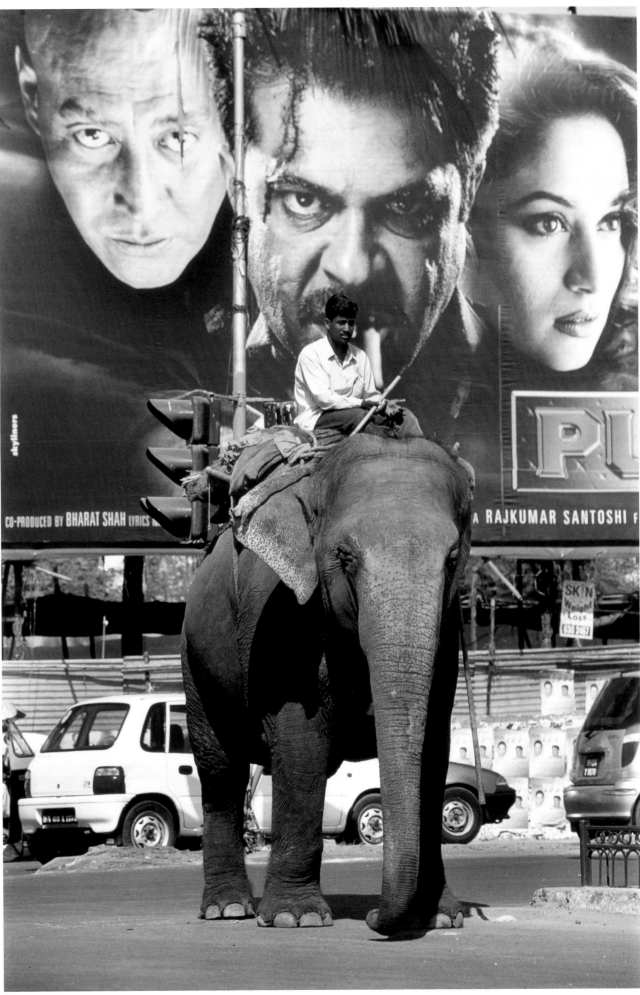

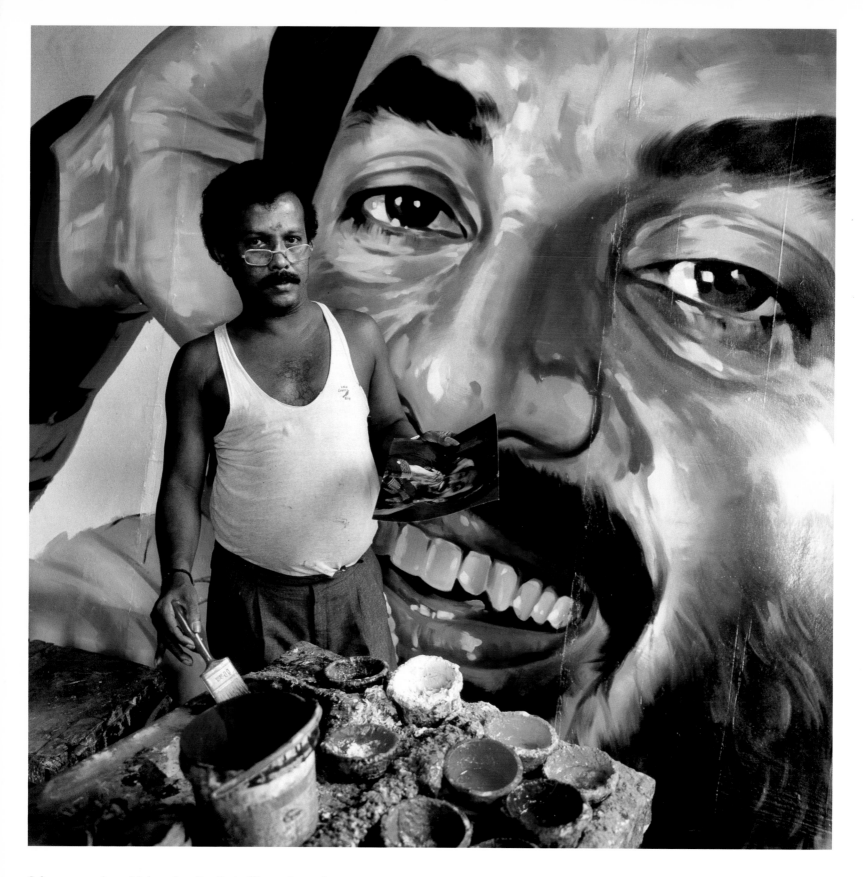

Selvam, an artist at Mohan Arts Studio in Chennai, stands in front of a freshly painted banner that will hang outside a cinema.

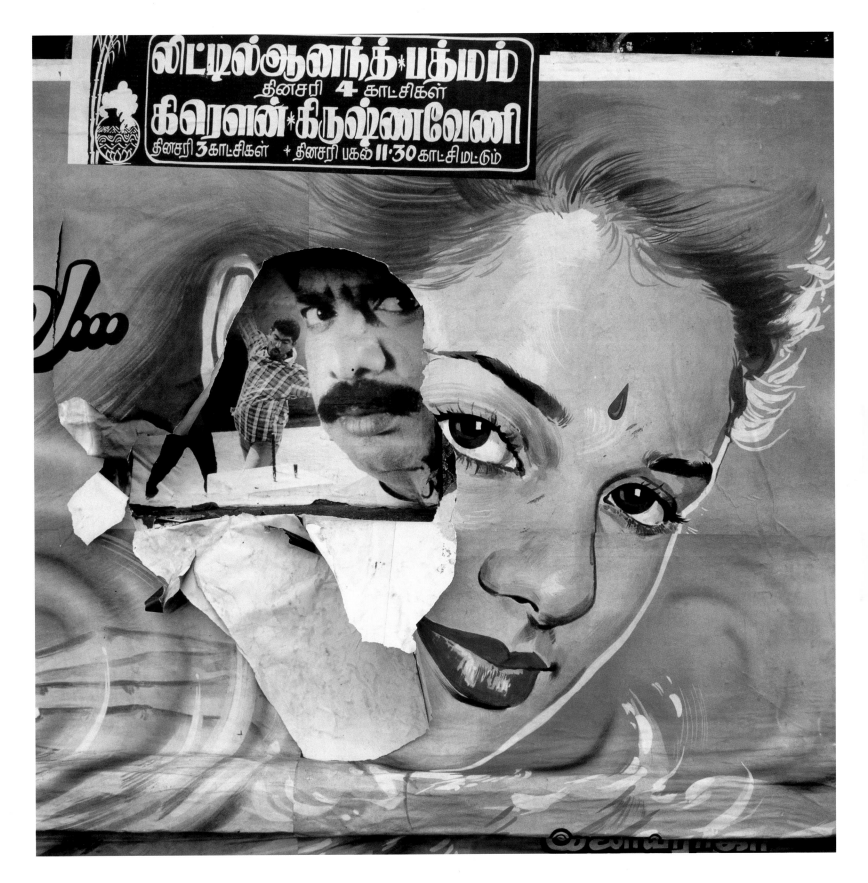

Torn cinema posters on a wall in Chennai. Cinema
banners and printed posters are placed on almost every
bare wall, turning the streets of Chennai and Mumbai
into gigantic collages of India's film stars.

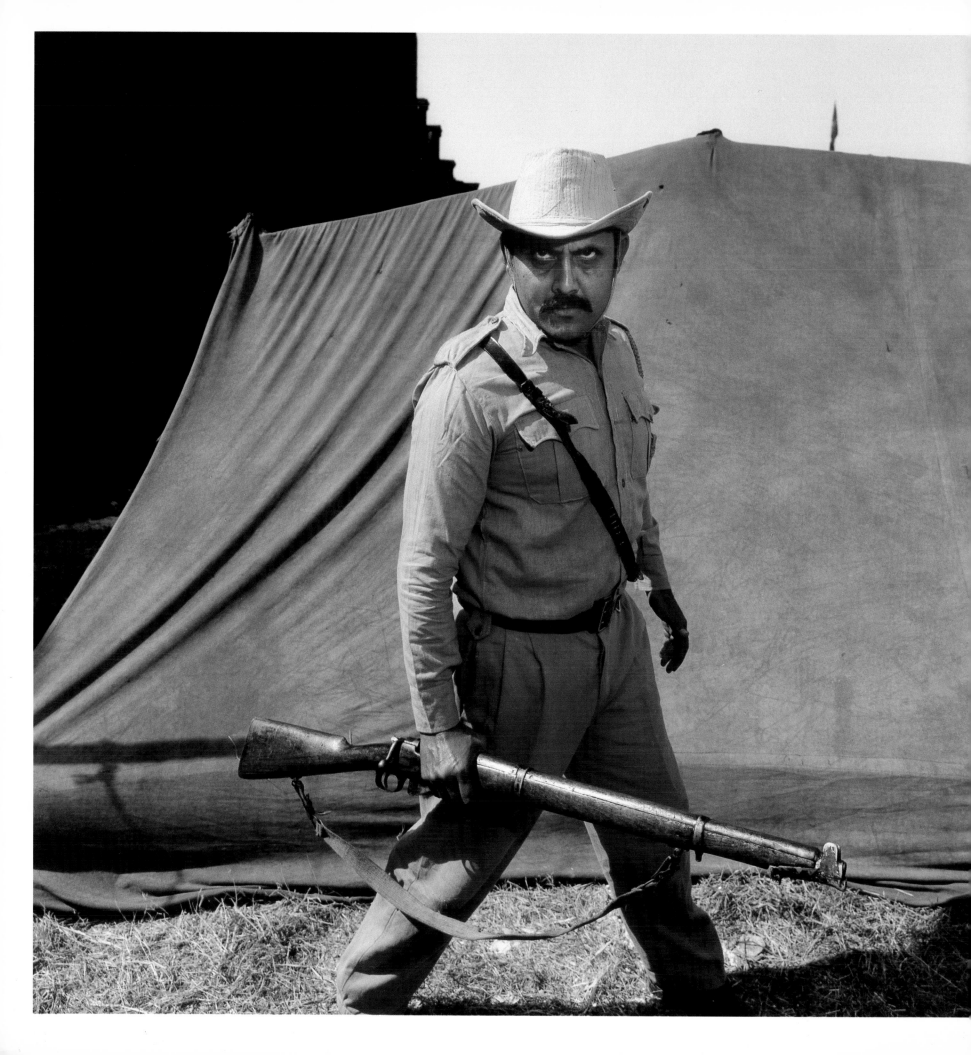

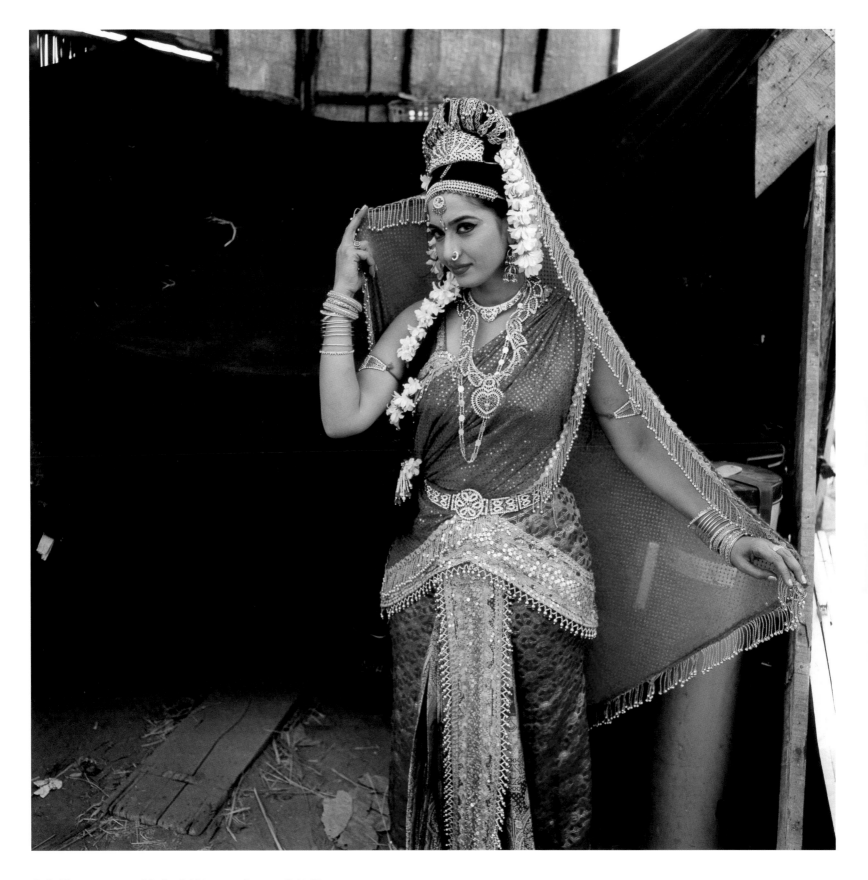

Left: Character actor Noshad Abbas on the set of *Ab Ke Baras* and, *above*, actress Lata Haya at Stage No. 9 in Film City, Mumbai.

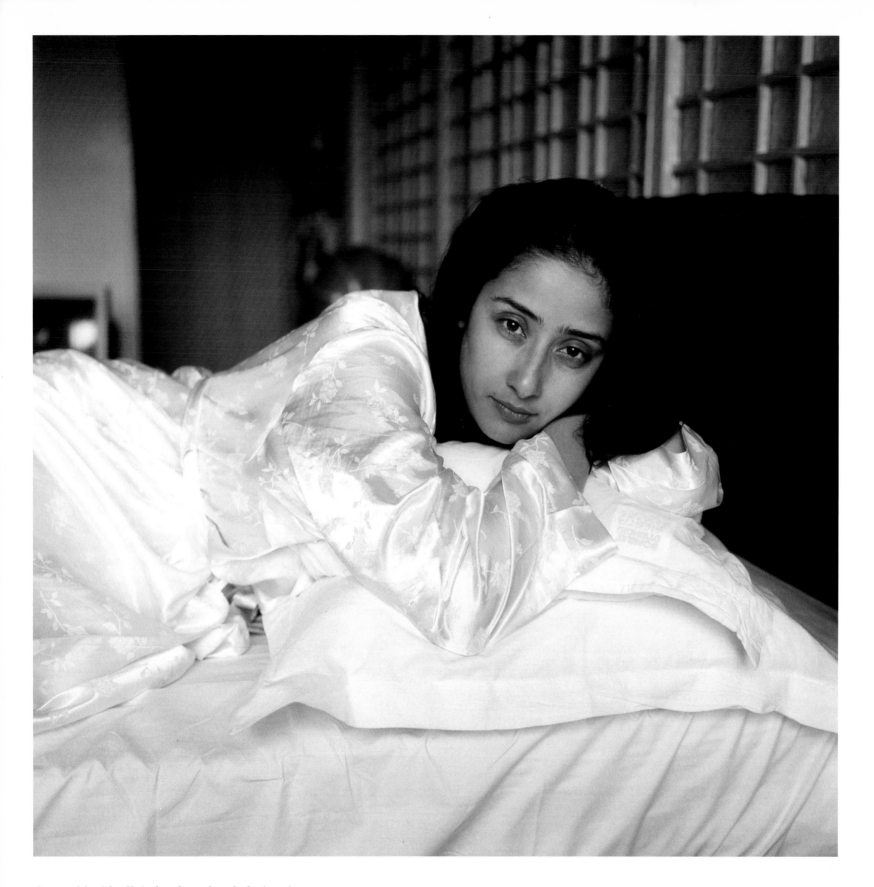

Actress Manisha Koirala takes a break during the
filming of *Champion* at Film City in Hyderabad. Koirala
is originally from Nepal and has acted in a number
of key Indian films by directors from both Mumbai
and Chennai, including in the hugely successful films
Bombay and *Dil Se* directed by Mani Ratnam.

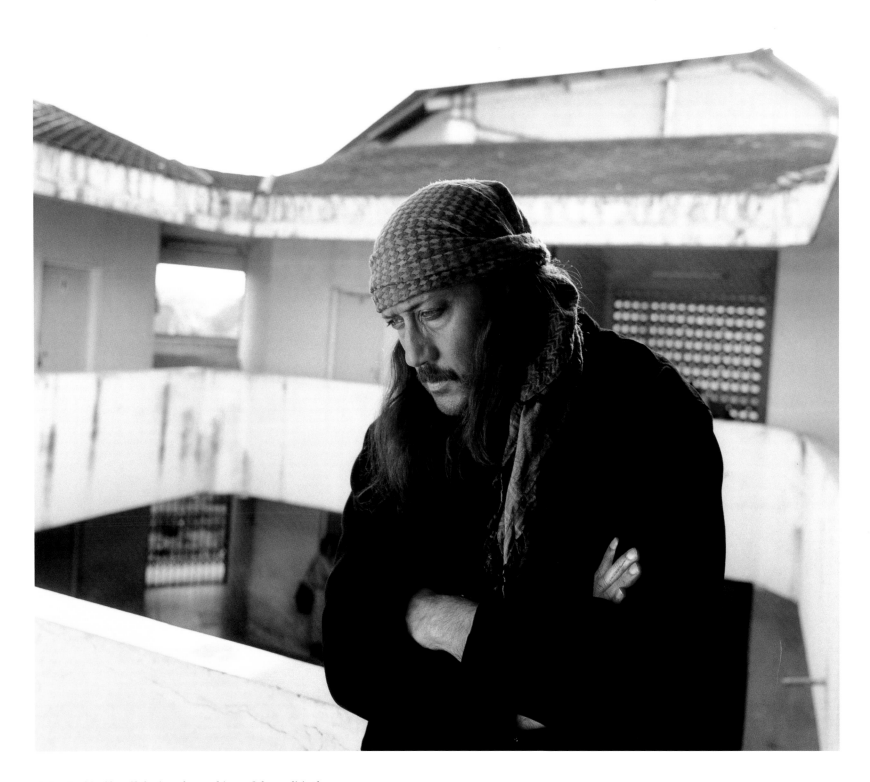

Actor Jackie Shroff during the making of the political melodrama *Mission Kashmir* at Film City in Mumbai.

Heroes in Indian films are almost always opposed by equally dynamic villains. These usually have huge moustaches and teary red eyes, and are modelled on demonic characters from Hindu epics such as the *Mahabharata* and the *Ramayana*.

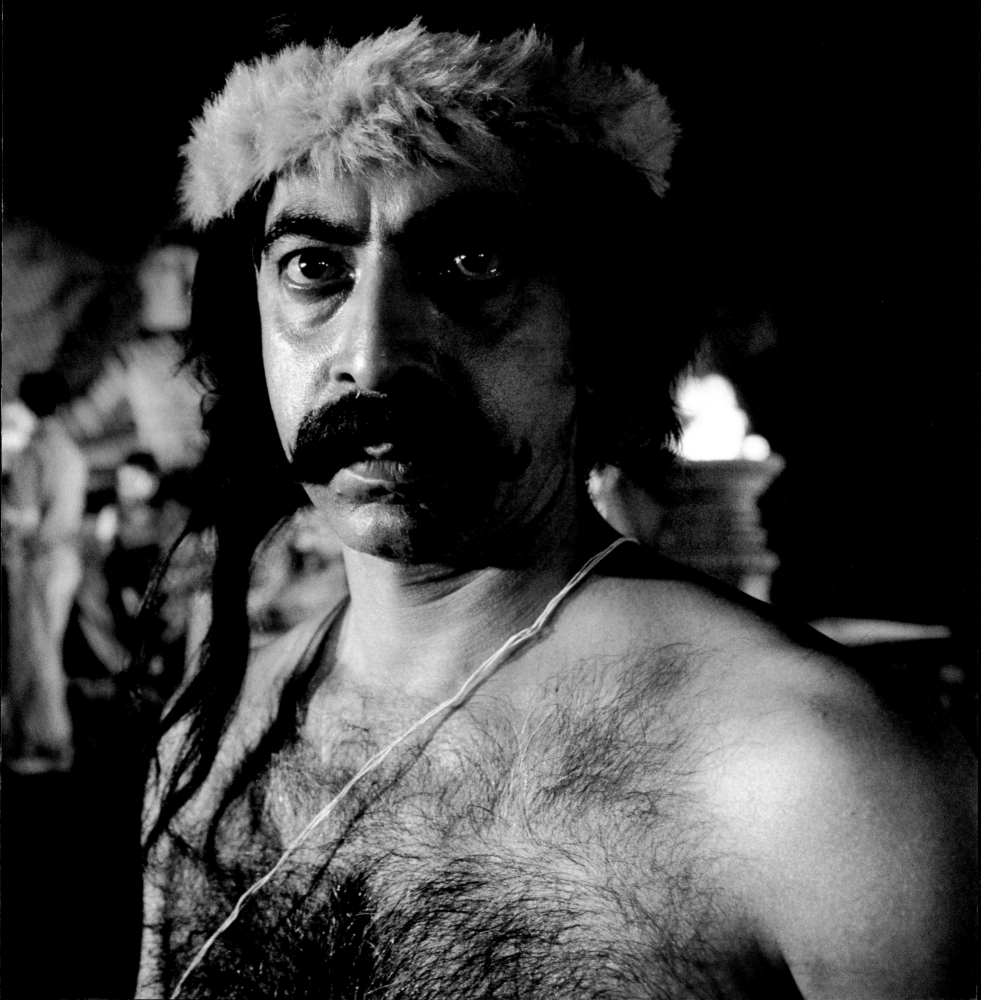

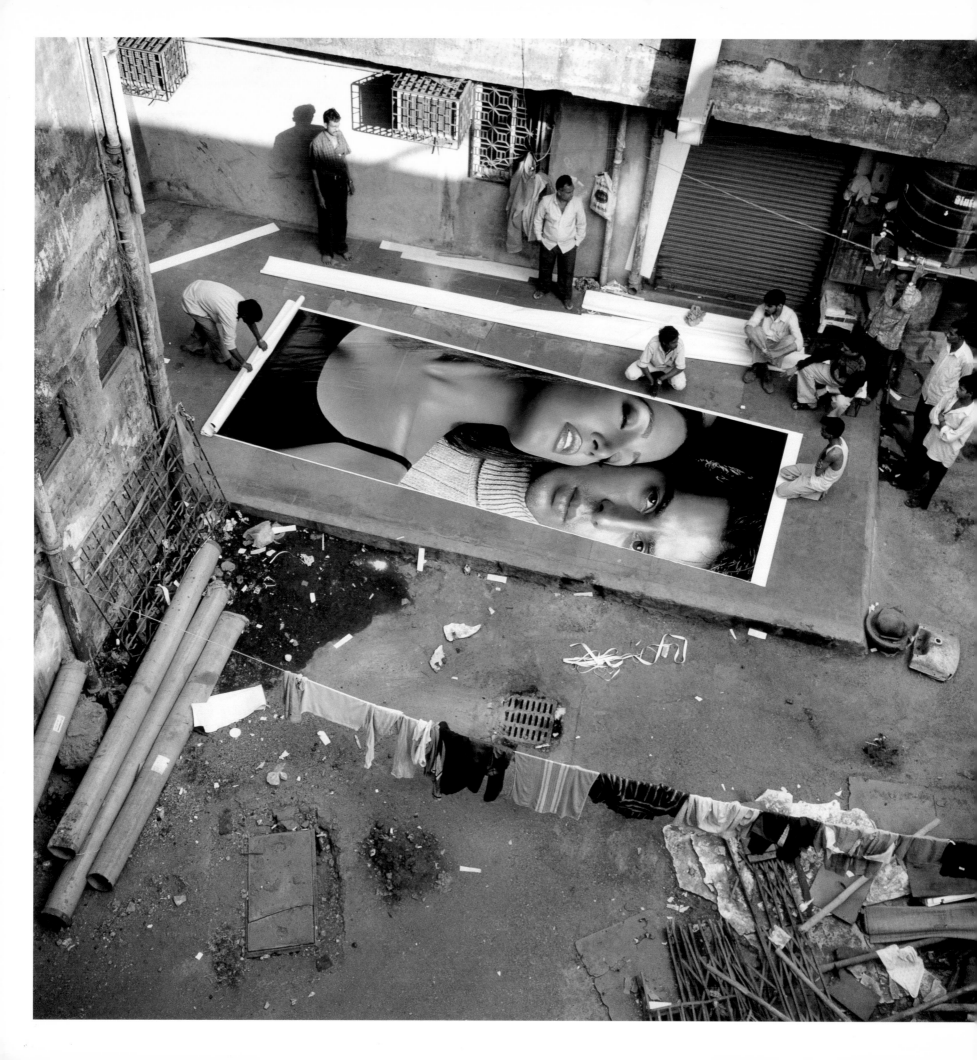

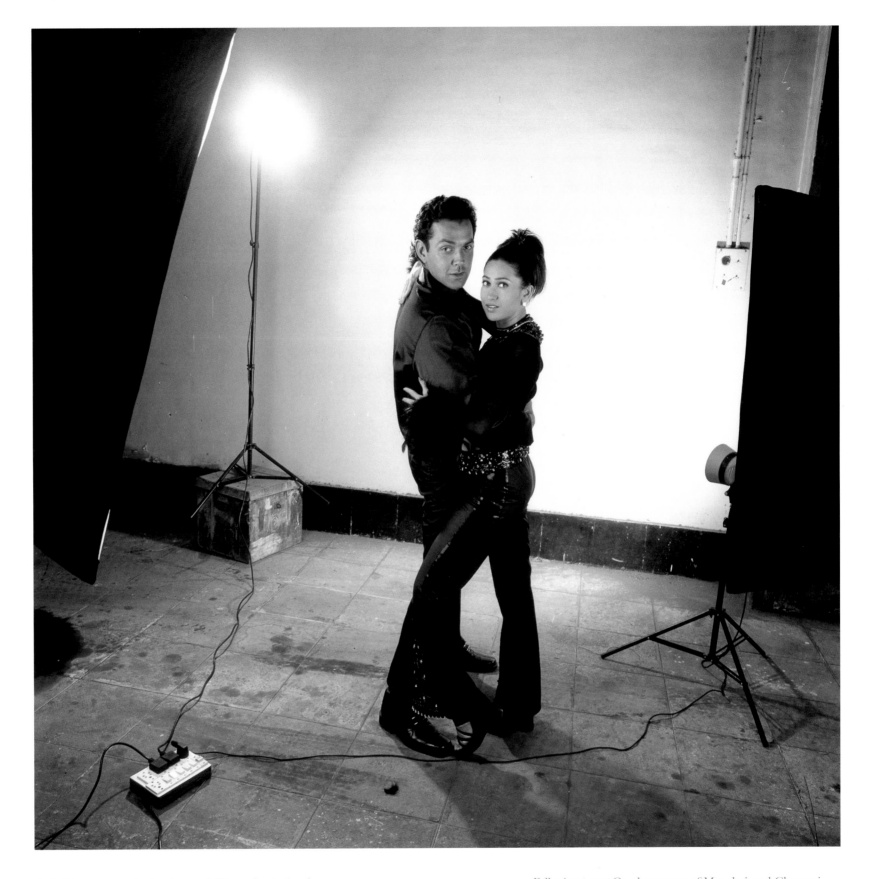

Left: The courtyard of a cinema billboard printing house in Mumbai. The billboard is printed in several sections and then reassembled as one enormous image. Here, the hero and heroine are far more Westernized in appearance than was the case in the past. *Above:* Actors Bobby Deol and Karishma Kapoor in the makeshift studio of celebrity photographer Avi Gowariker at Mumbai's Raj Kamal Studios during a publicity photo shoot for their forthcoming film *Hum To Mohabbat Karega.*

Following pages: On the streets of Mumbai and Chennai cinema banners and posters cover almost every bare street wall, and postcards and memorabilia of film stars are sold on the streets. The idea of 'Darshan', the sighting of a god, is a vital part of prayer in India. By virtue of their superstardom and godlike status in Indian society, images of film stars take on powerful meaning and can be revered as much as images of icons, such as Mahatma Gandhi, and Hindi gods and goddesses.

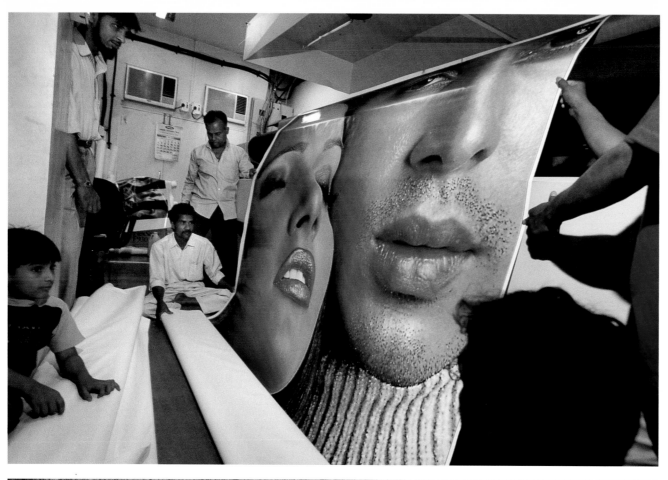
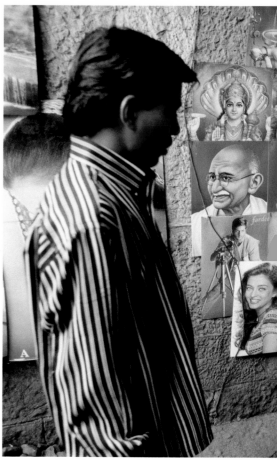
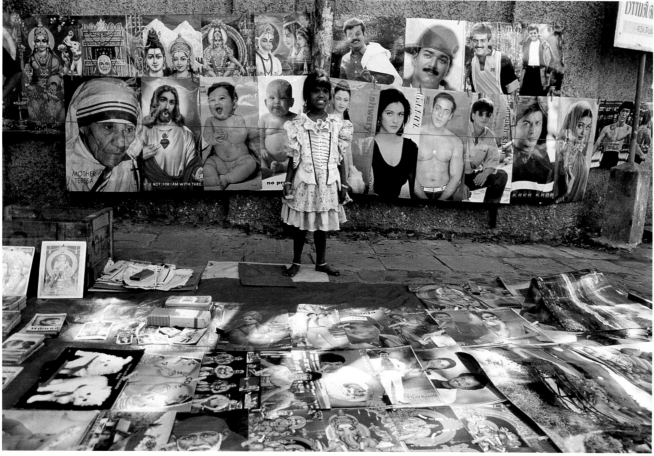
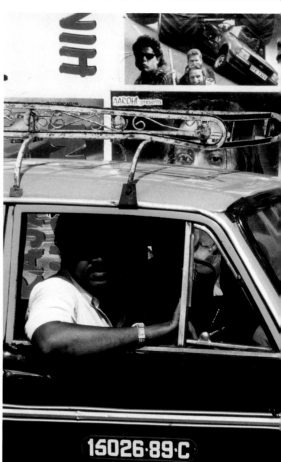

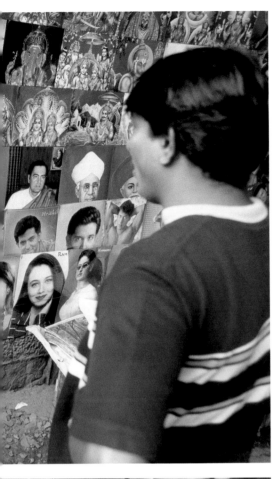

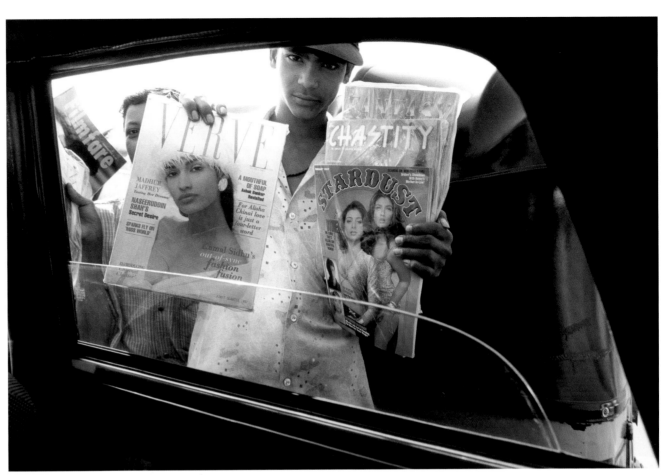

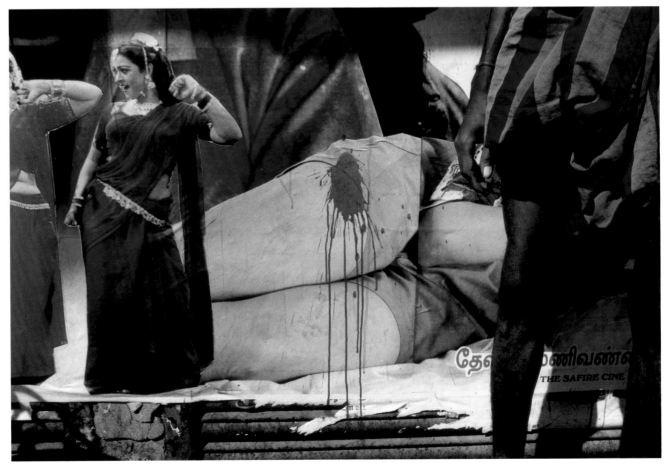

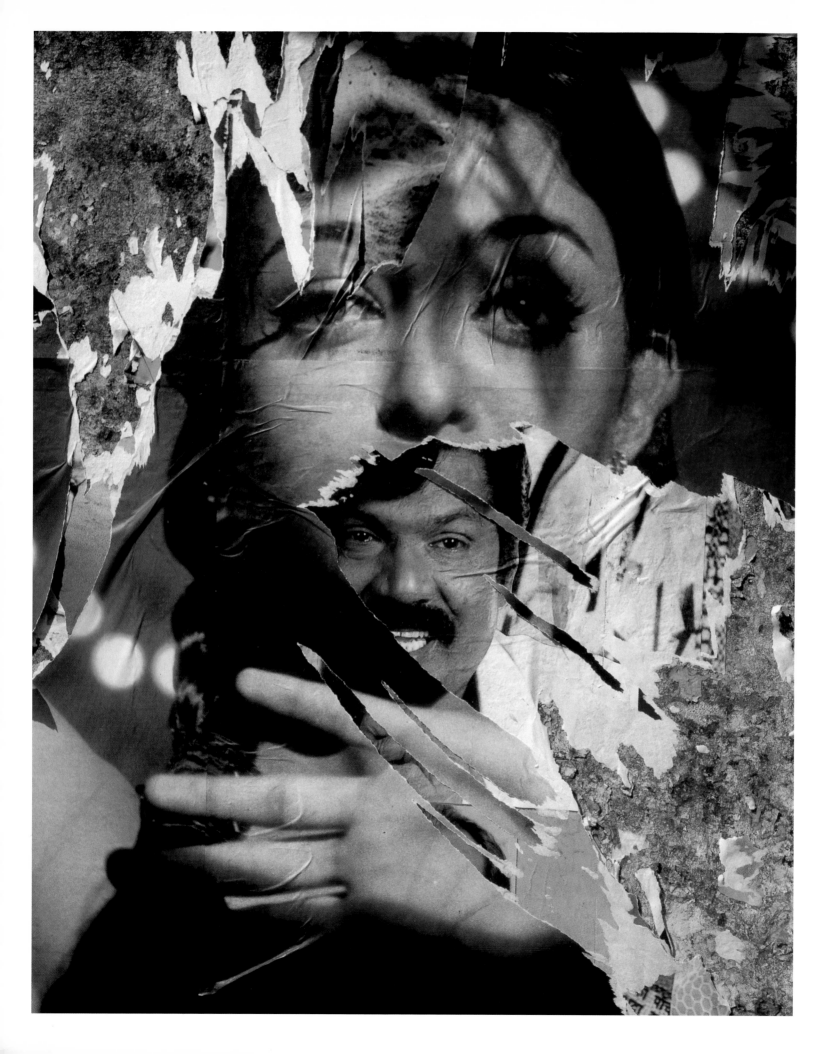

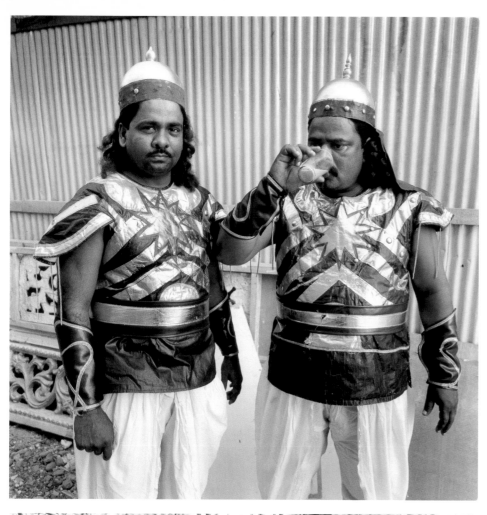
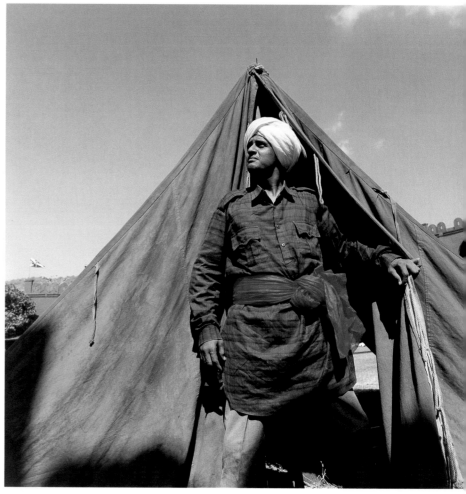
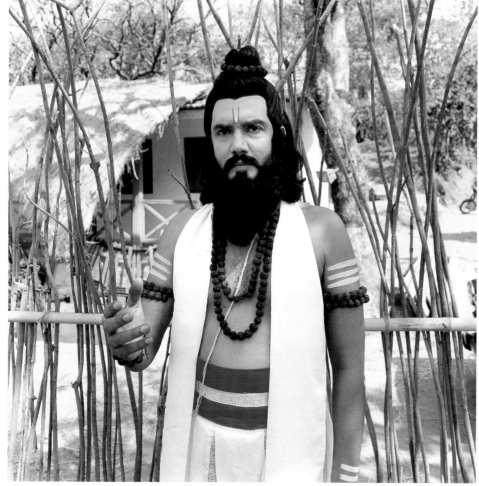

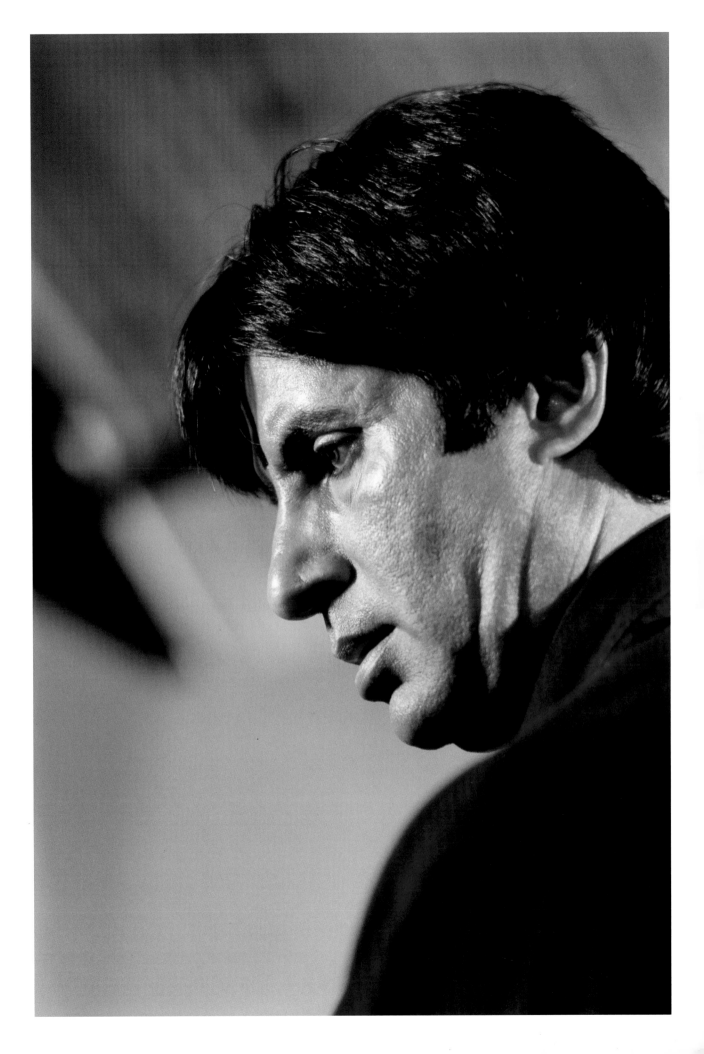

Filmistan Studios in Mumbai.

Bachchan, now in his sixties. When he had a near fatal accident in 1982, one of his millions of fans walked backwards for more than 300 miles as an offering to God to pray for his recovery.

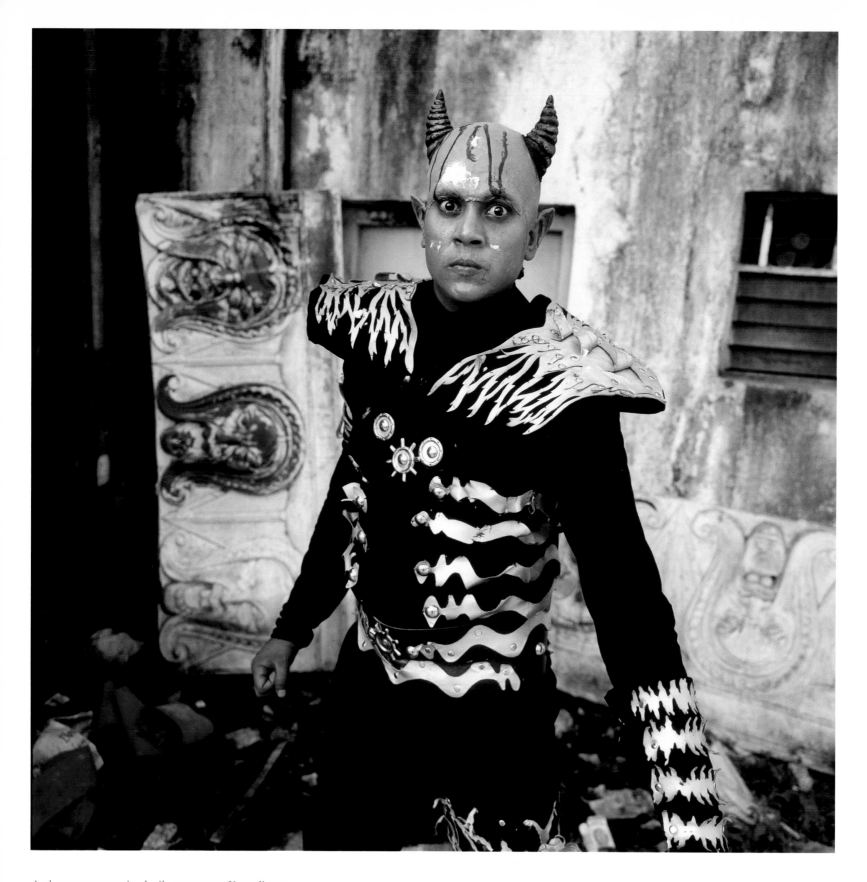

A character actor in devil costume at Kamalistan
Studios, Mumbai.

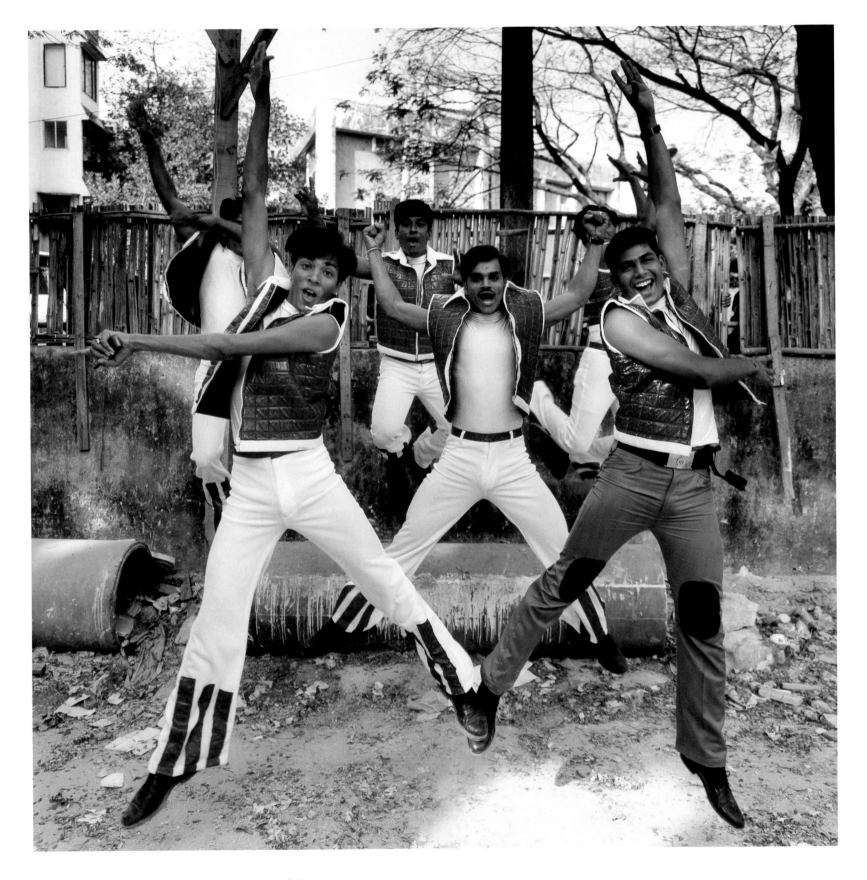

Dancers practise a dance sequence on the set of *Chor Mach Shor* at Filmalaya Studios, Mumbai.

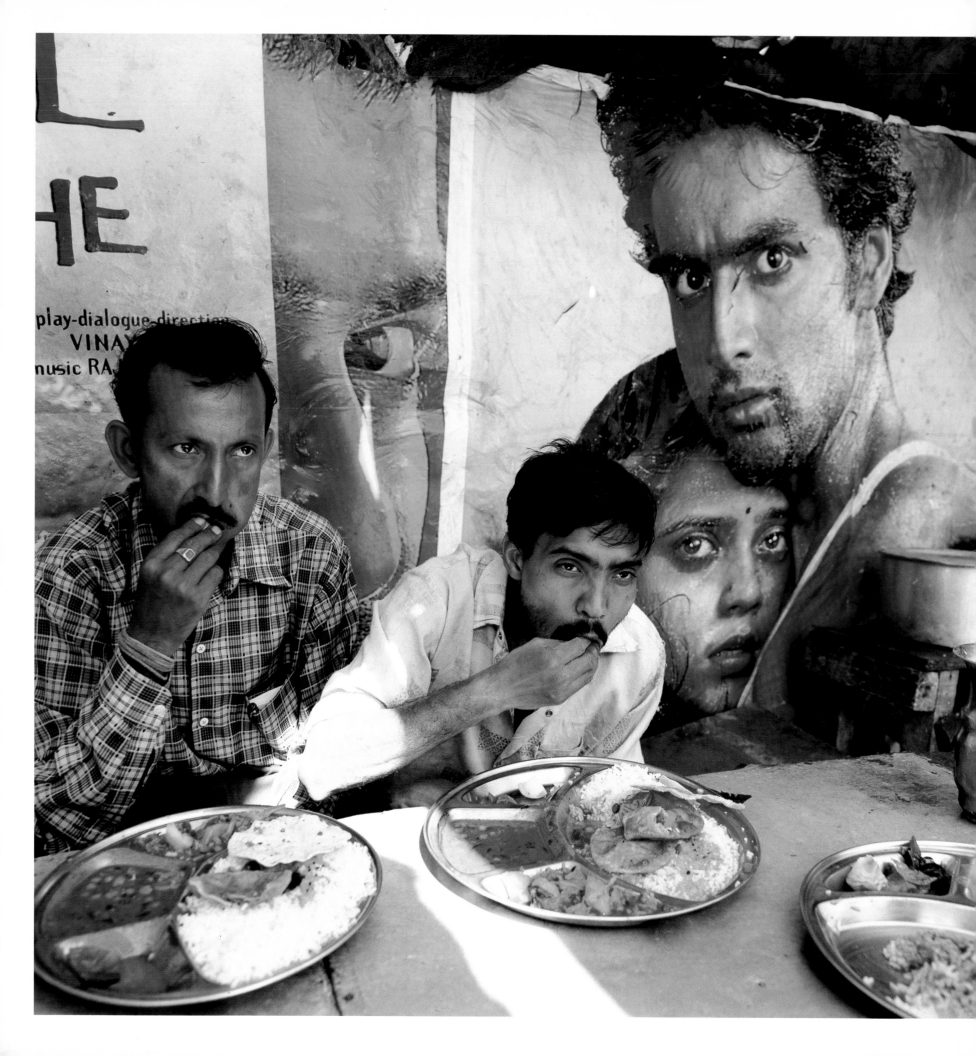

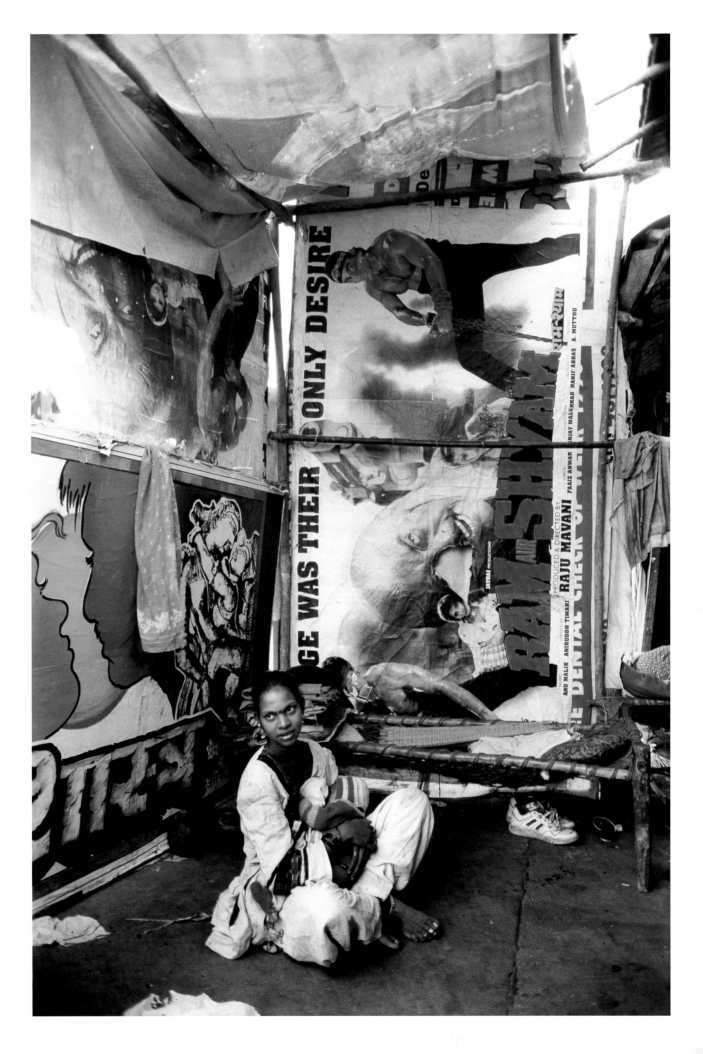

Mumbai is covered wall-to-wall with cinema posters.

sits with her newborn baby in a makeshift home that has been constructed from old cinema banners.

The memorial stone of M.G. Ramachandran, a great actor and politician from the state of Tamil Nadu. His devotees believe that if you are lucky you might hear his voice at his memorial site. Every day hundreds of fans flock to the site near the beach in Chennai.

at the cinema

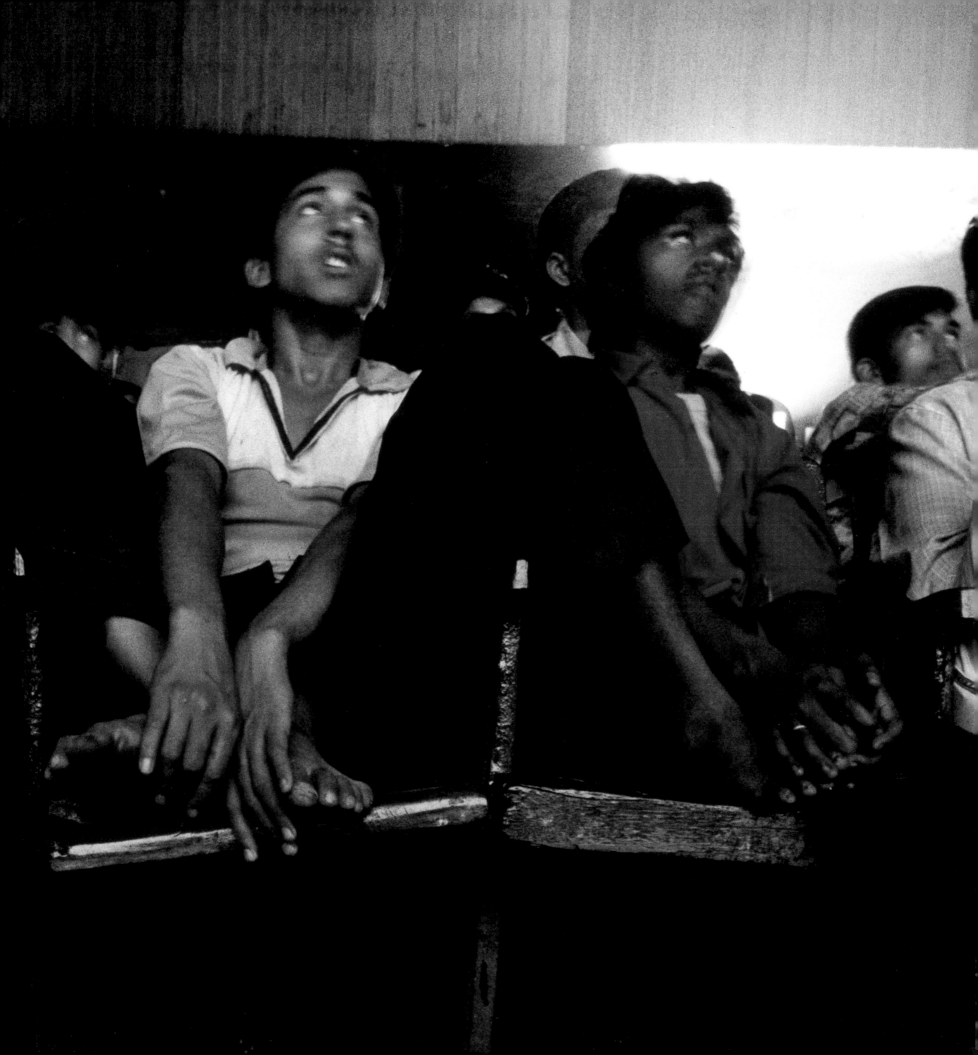

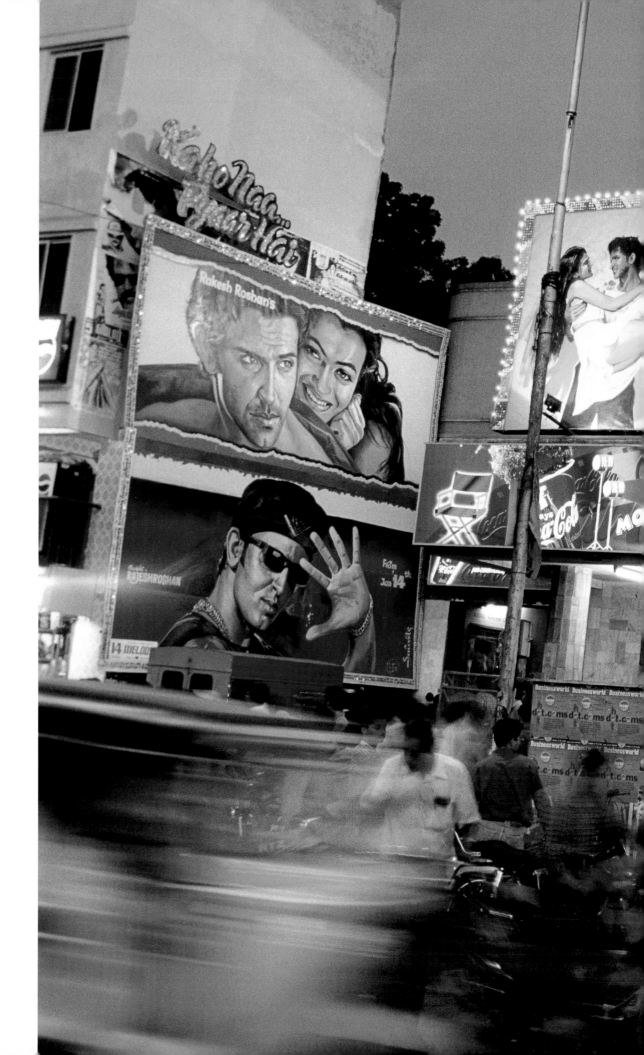

A typical scene outside the Melody Cinema, Chennai. This film, *Kaho Naa Pyaar Hai*, launched the career of heart-throb Hritik Roshan in 2000.

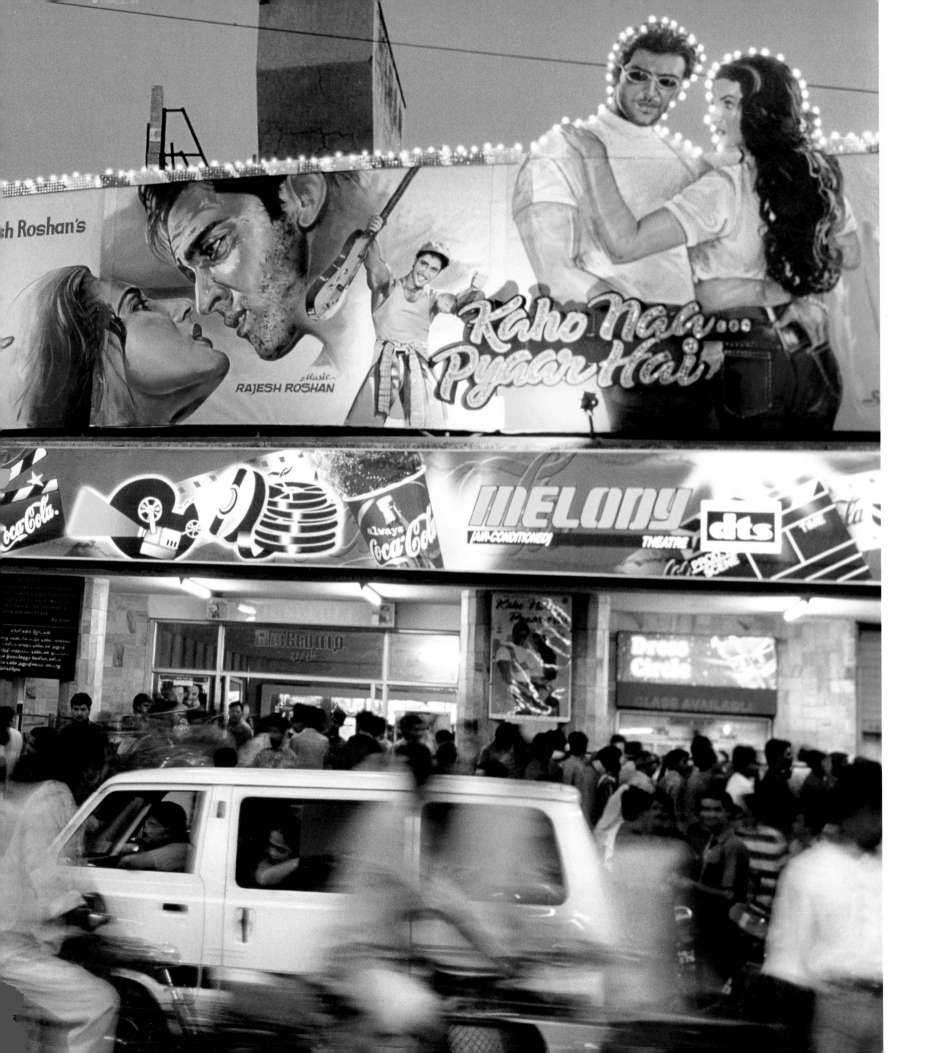

Clockwise from top left: Women in line reach into the ticket booth at the Abirami Cinema in Chennai; young men queue outside Chennai's Roopam Cinema, and one of them displays a photo of film megastar Rajnikanth that he carries in his wallet; at the box office of the Imperial Cinema in Mumbai, competition to get a good position in the queue to buy tickets is so fierce that the cinema owners hire guards to keep order.

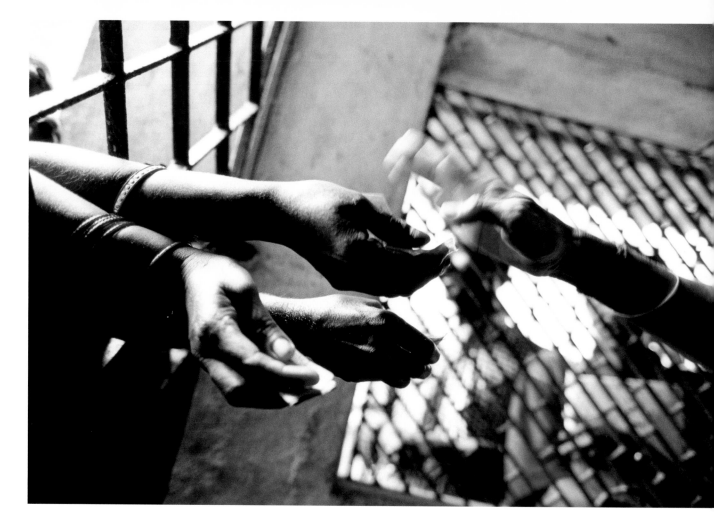

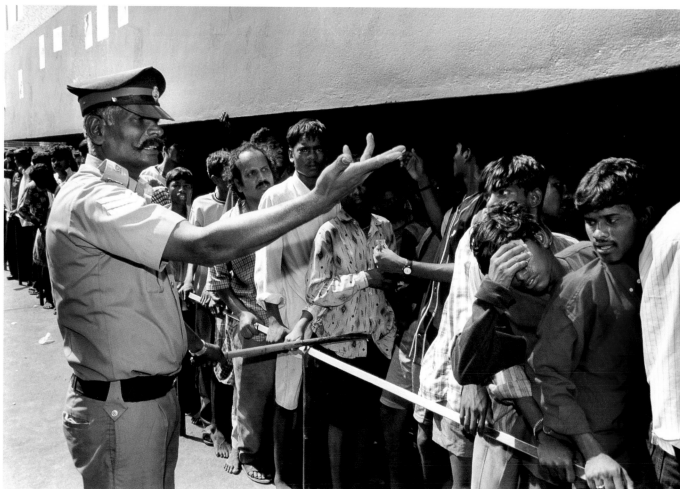

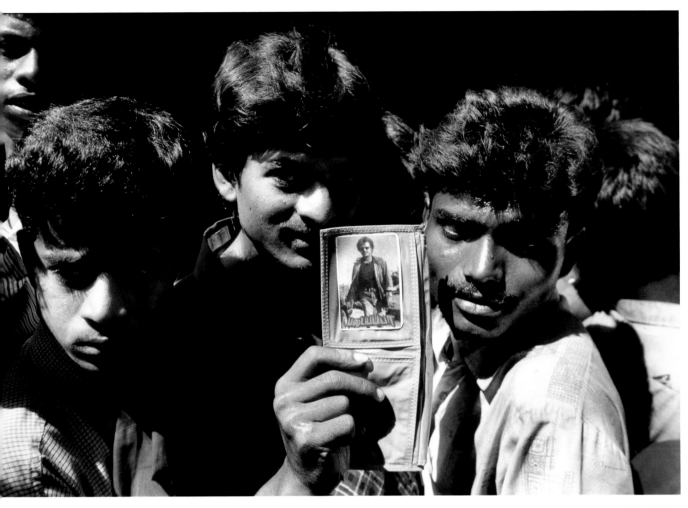

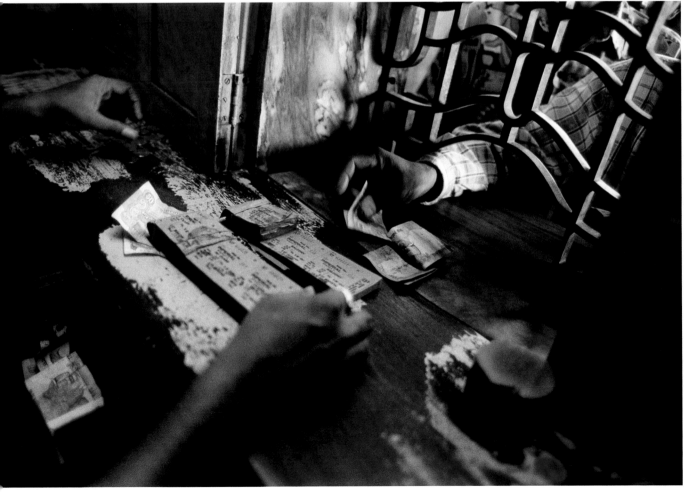

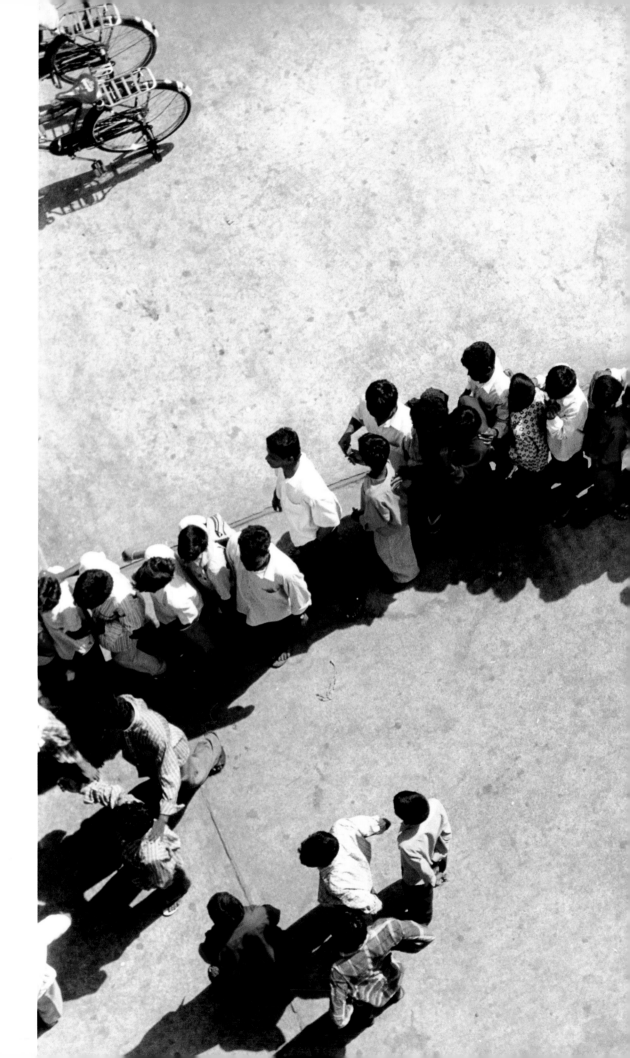

Approximately 14 million Indians queue each day to go to the movies. This queue has formed outside the Abirami Cinema in Chennai for the matinee show.

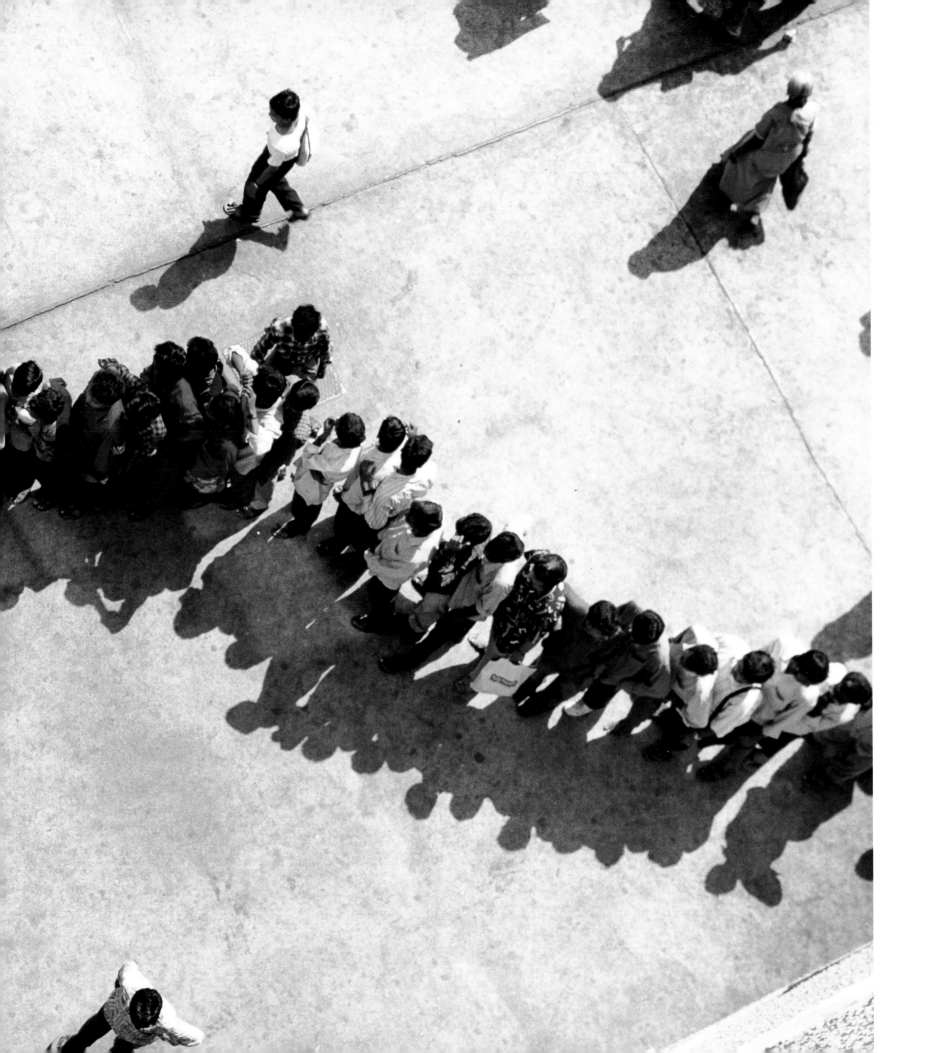

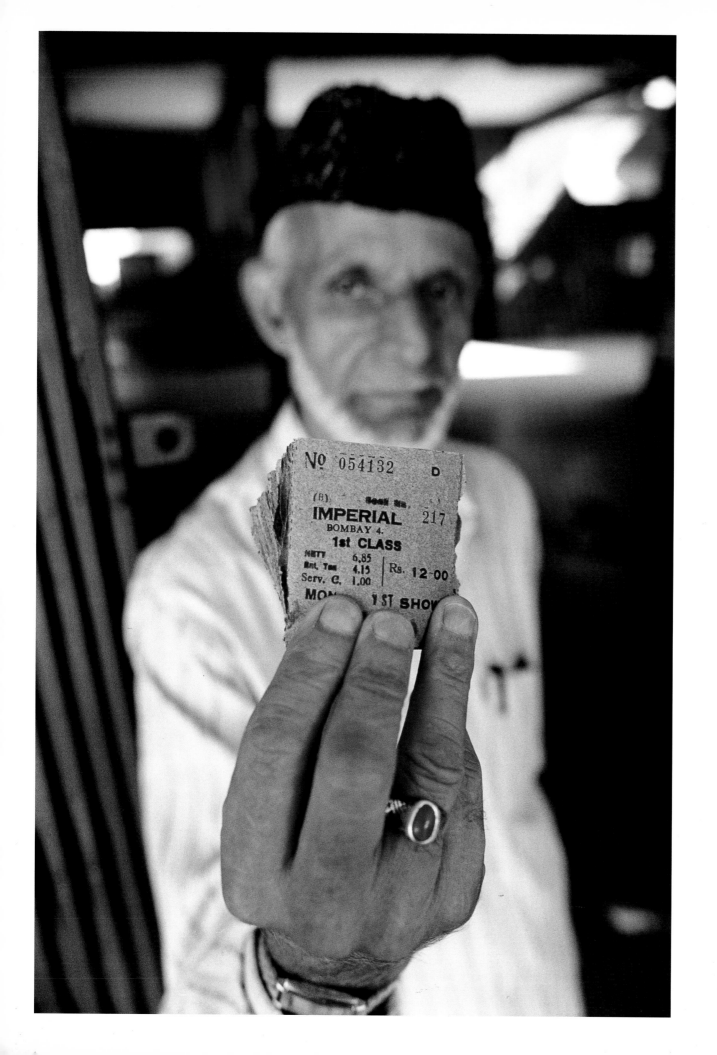

An usher displays tickets collected at the eighty-year-old
Imperial Cinema, one of the oldest cinemas in Mumbai.
Tickets cost 12 rupees (about US $0.25) for a three-

for women and men. This stems from the social convention within much of Indian society that women prefer not to be in close proximity to men they do not know.

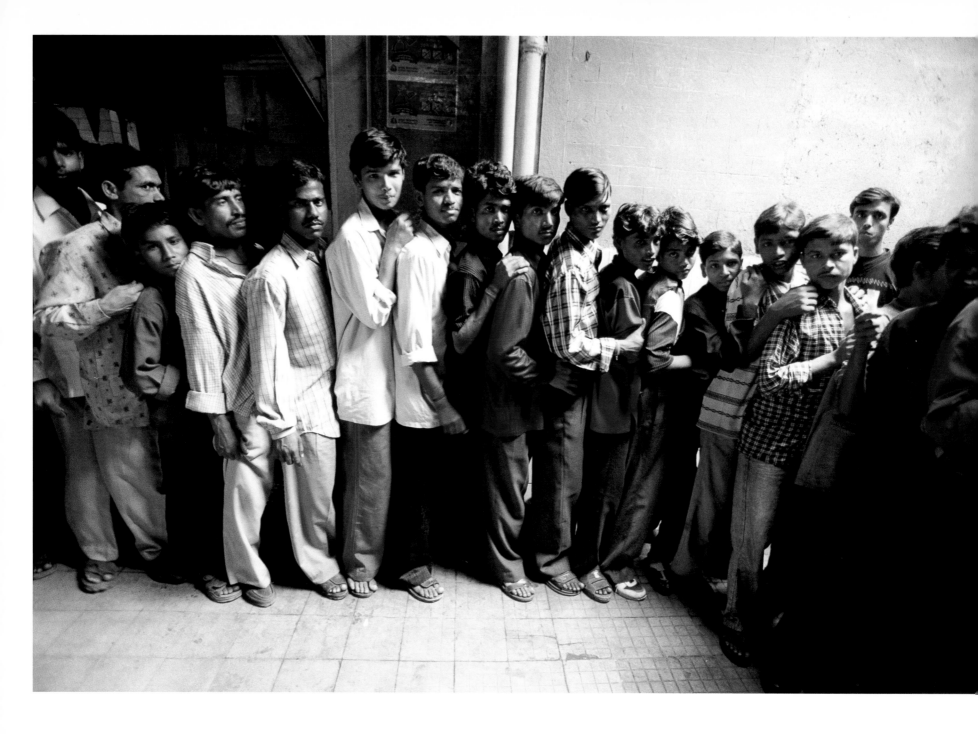

It is mostly men who gather for this action movie showing at the New Roshan Cinema near Grant Road Station in Mumbai, and there is fierce competition for a good position in the ticket queue.

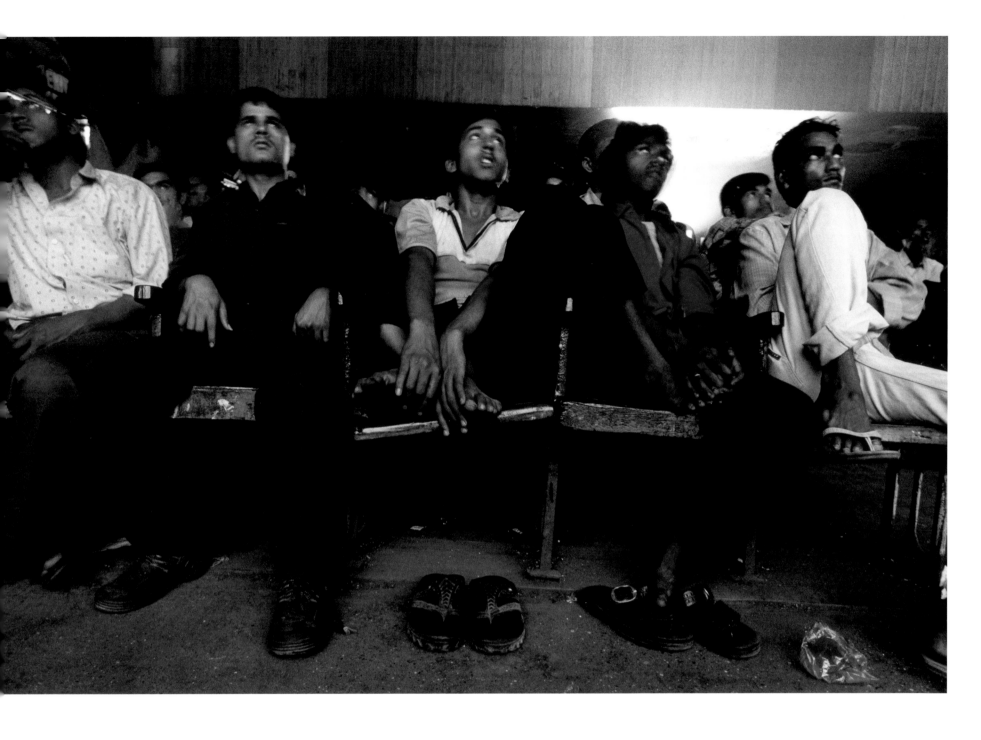

ew Shirin Talkies Cinema in Mumbai. Cinemas are
sually divided into sections according to ticket price.
he biggest fans sit in the front row.

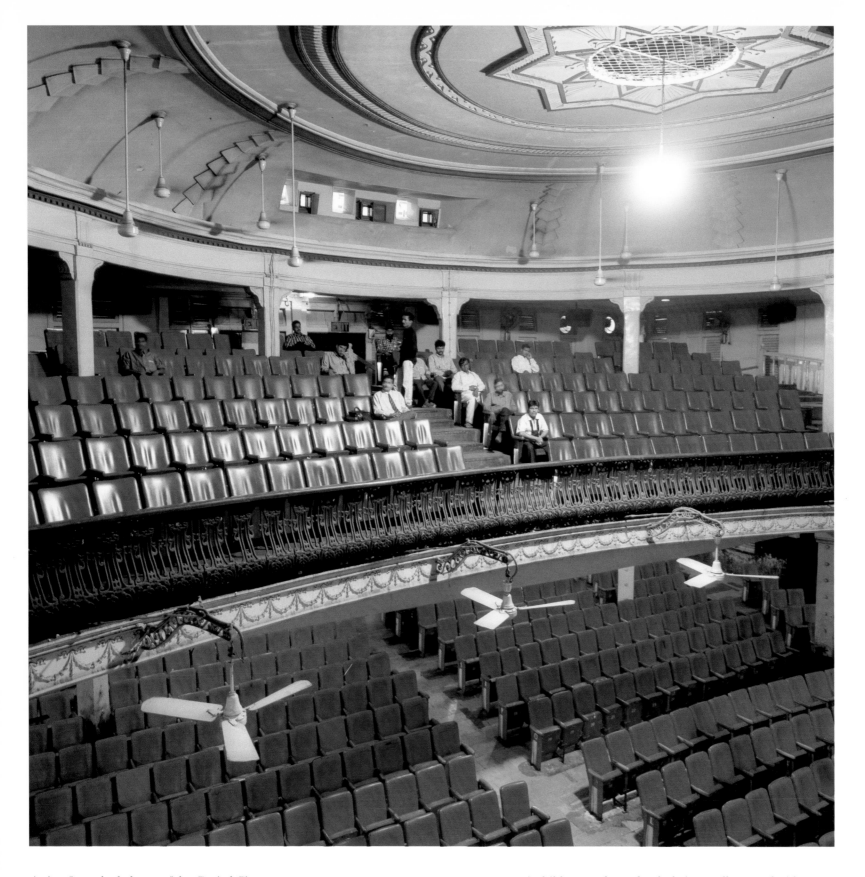

A view from the balcony of the Capital Cinema, Mumbai. This single-screen cinema shows three to four films each day.

A child peeps through a hole in a wall covered with film posters in the courtyard of the Abirami Cinema in Chennai.

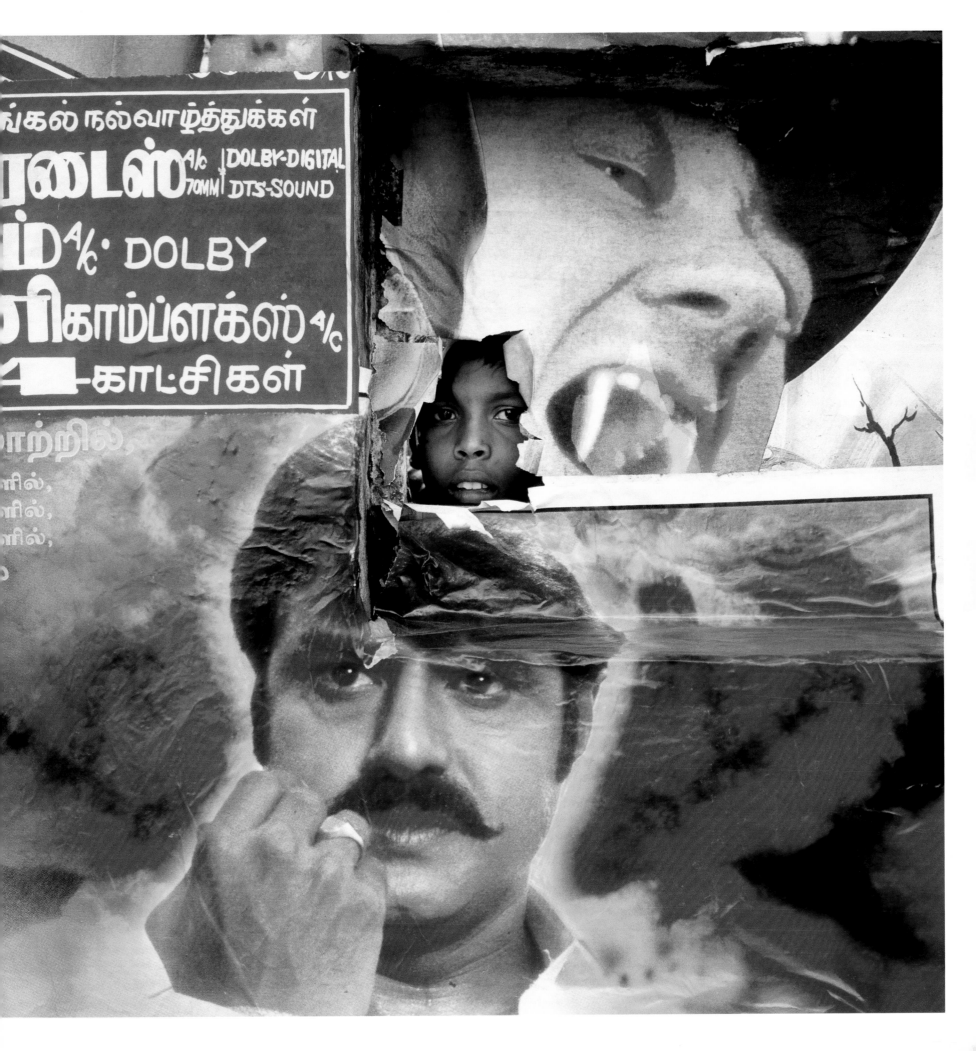

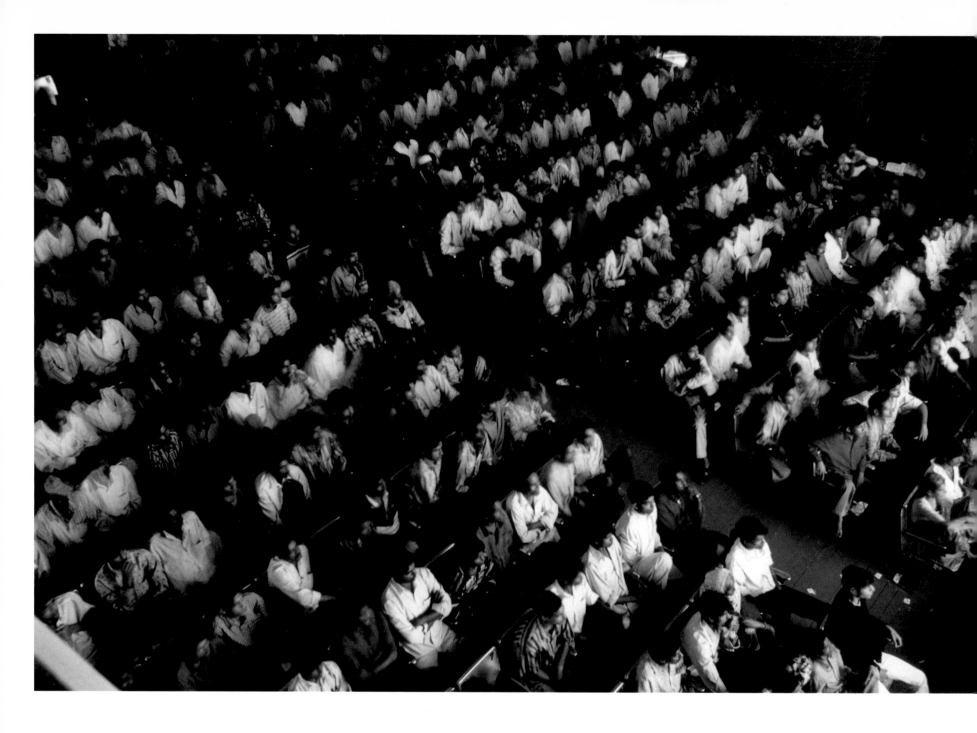

A view from the balcony of the New Shirin Talkies
Cinema in Mumbai during a film.

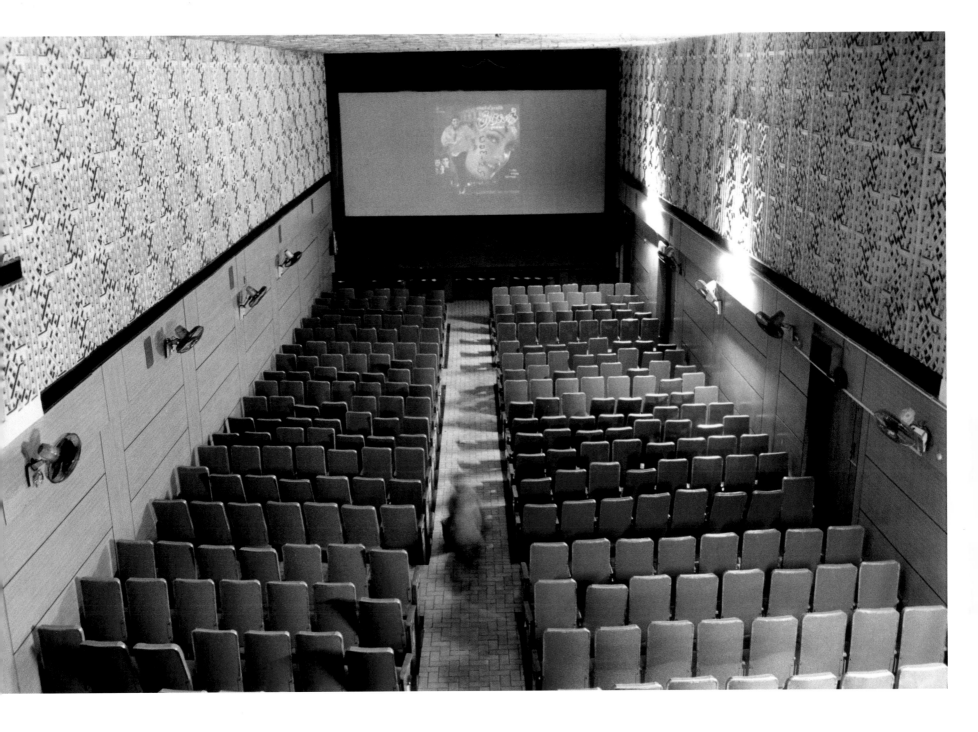

With the absence of air conditioning in many Indian cinemas, electric fans are used to keep the audience cool. The noise of the fans often competes with the movie's sound, forcing the film to be played at a very high volume. Padmam Cinema, Chennai.

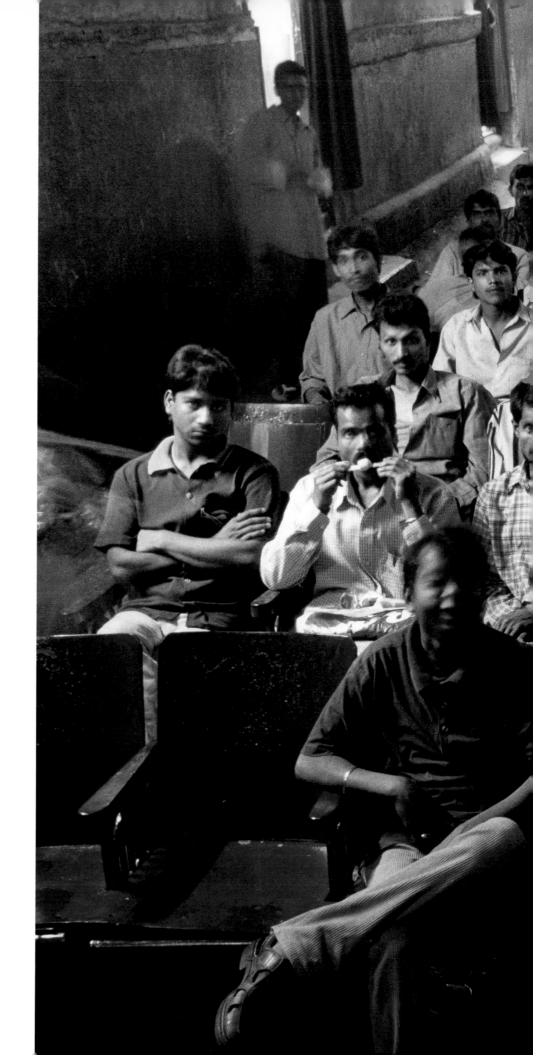

A sold-out matinee at the Alfred Talkies Cinema, Mumbai. Working-class men make up most of the audience at the many cinemas near Grant Road station.

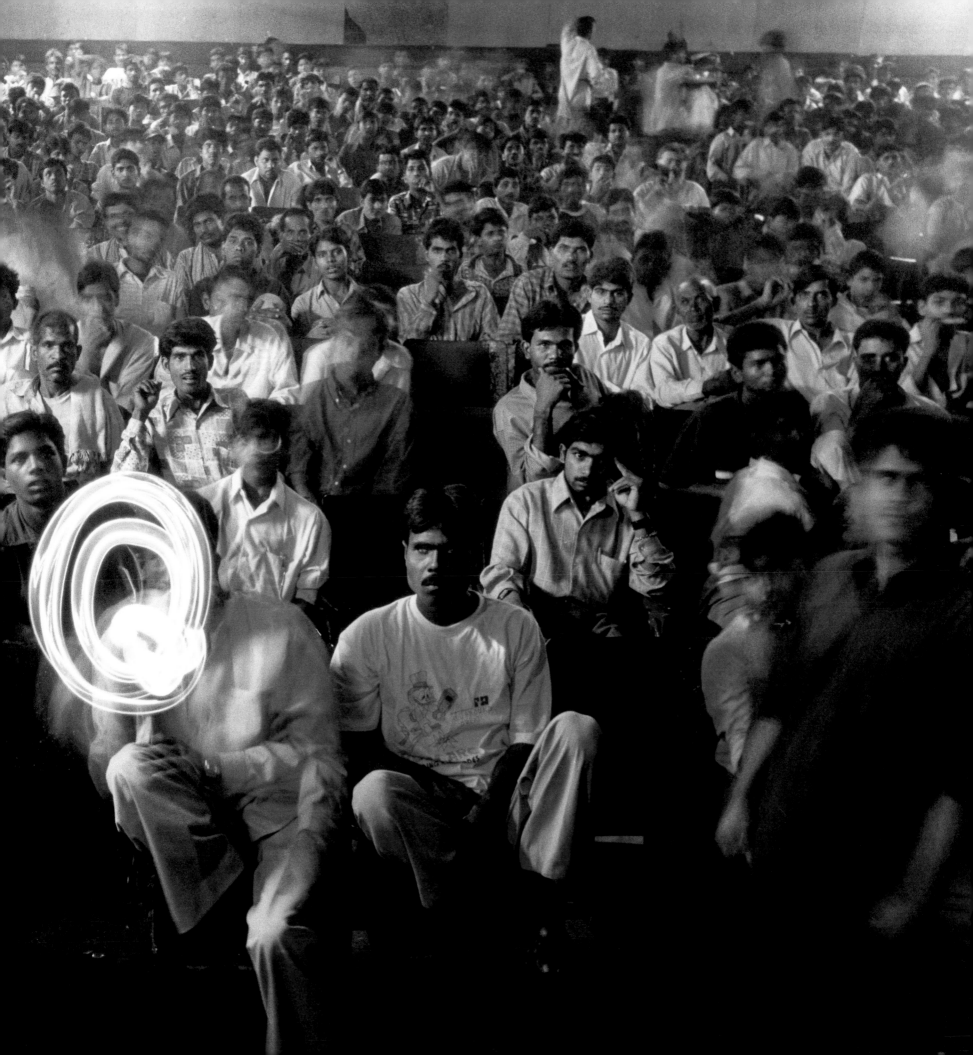

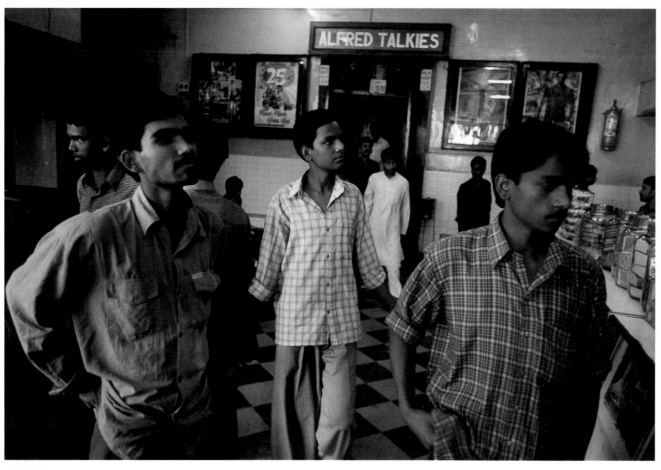

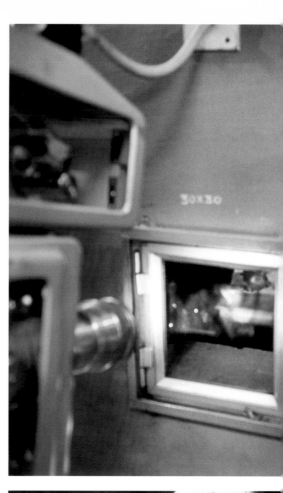

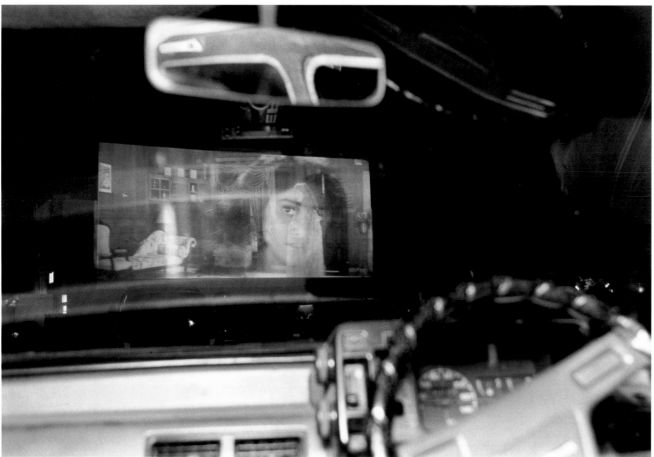

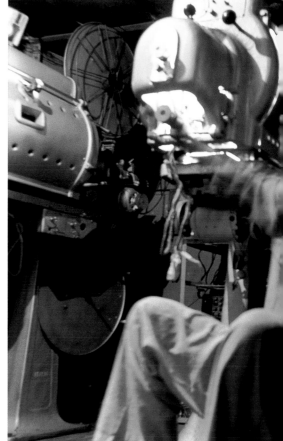

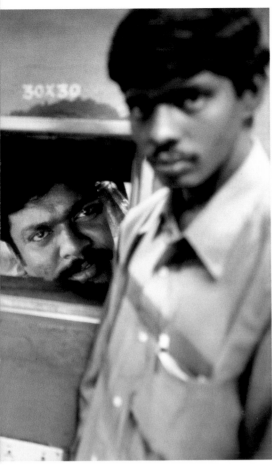
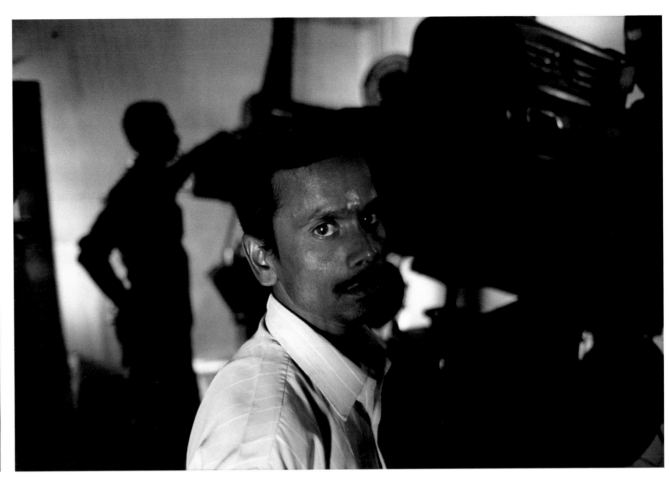
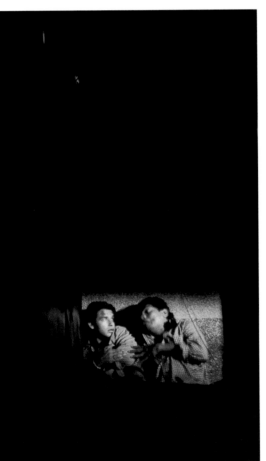
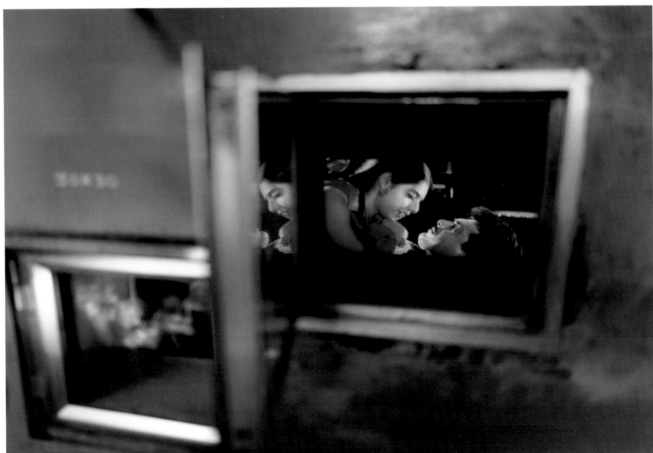

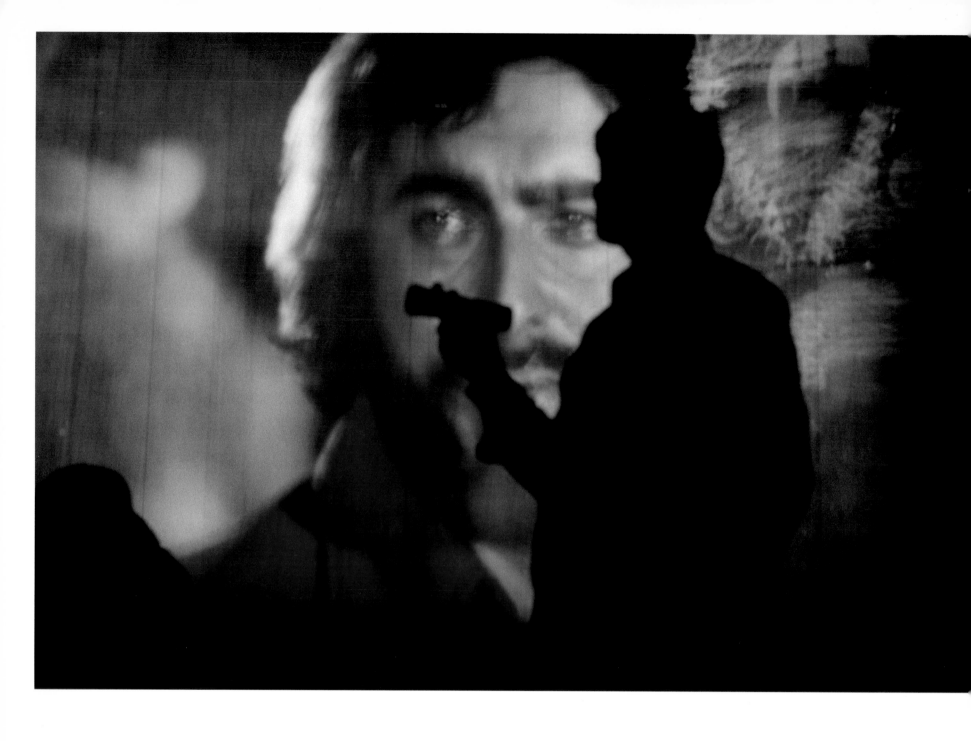

Previous pages, clockwise from top left: The Alfred Talkies Cinema in Mumbai during intermission; behind the scenes with the projectionists; at the Prarthana Drive-In Beach Cinema in Chennai.

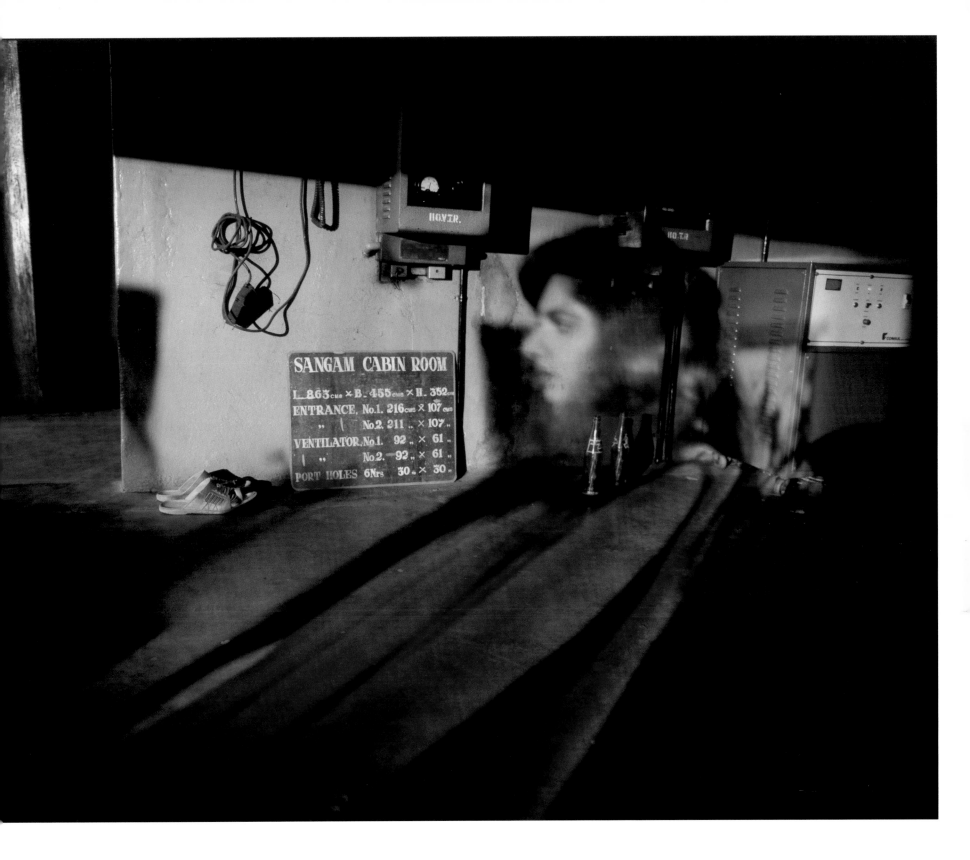

Text visible within the photograph:

SANGAM CABIN ROOM
L. 863 cms × B. 455 cms × H. 352 cms
ENTRANCE. No.1. 216 cms × 107 cms
 ,, No.2. 211 ,, × 107 ,,
VENTILATOR. No.1. 92 ,, × 61 ,,
 ,, No.2. 92 ,, × 61 ,,
PORT HOLES 6Nrs 30 ,, × 30 ,,

bove left: An usher directs movie-goers to their seats
the Alfred Talkies Cinema, Mumbai. *Above:* A film's
flection on the floor and wall of the projection room
the Sangam Cinema, Chennai.

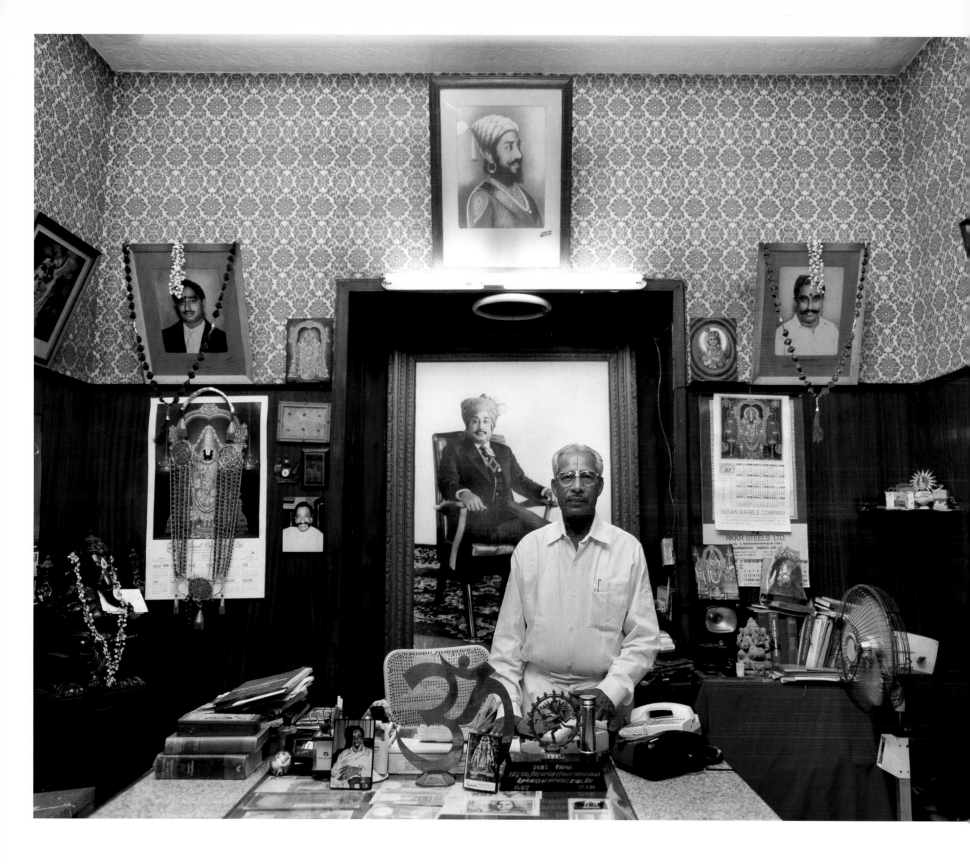

Mr K. Venugopal, manager of the Shanti Cinema
in Chennai.

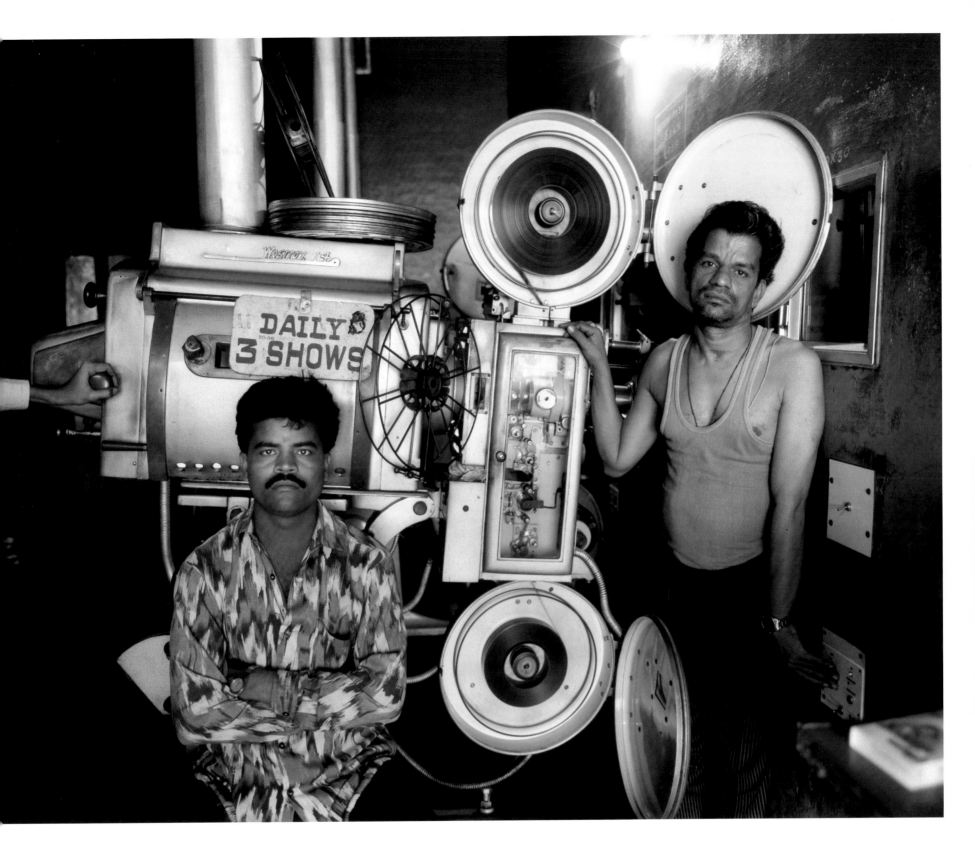

Projectionists at the Padmam Cinema in Chennai. Older projectors such as this one often produce dim images with poor focus and sound.

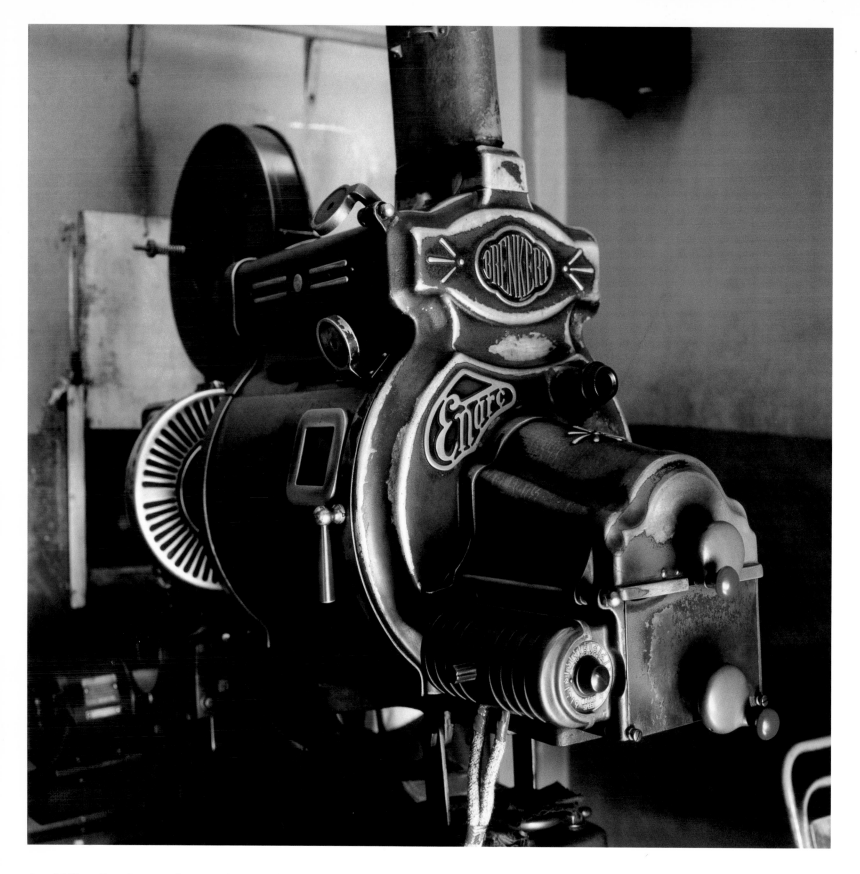

An old 'Enarc' arc lamp projector at the New Shirin
Talkies Cinema in Mumbai, still in daily use.

Right: A projectionist at the Shanti Cinema in Chennai.
Projectionists tend to work long hours and each typically
shows a minimum of four shows each day. At times,
the heat given off by the projectors makes the room
unbearably hot.

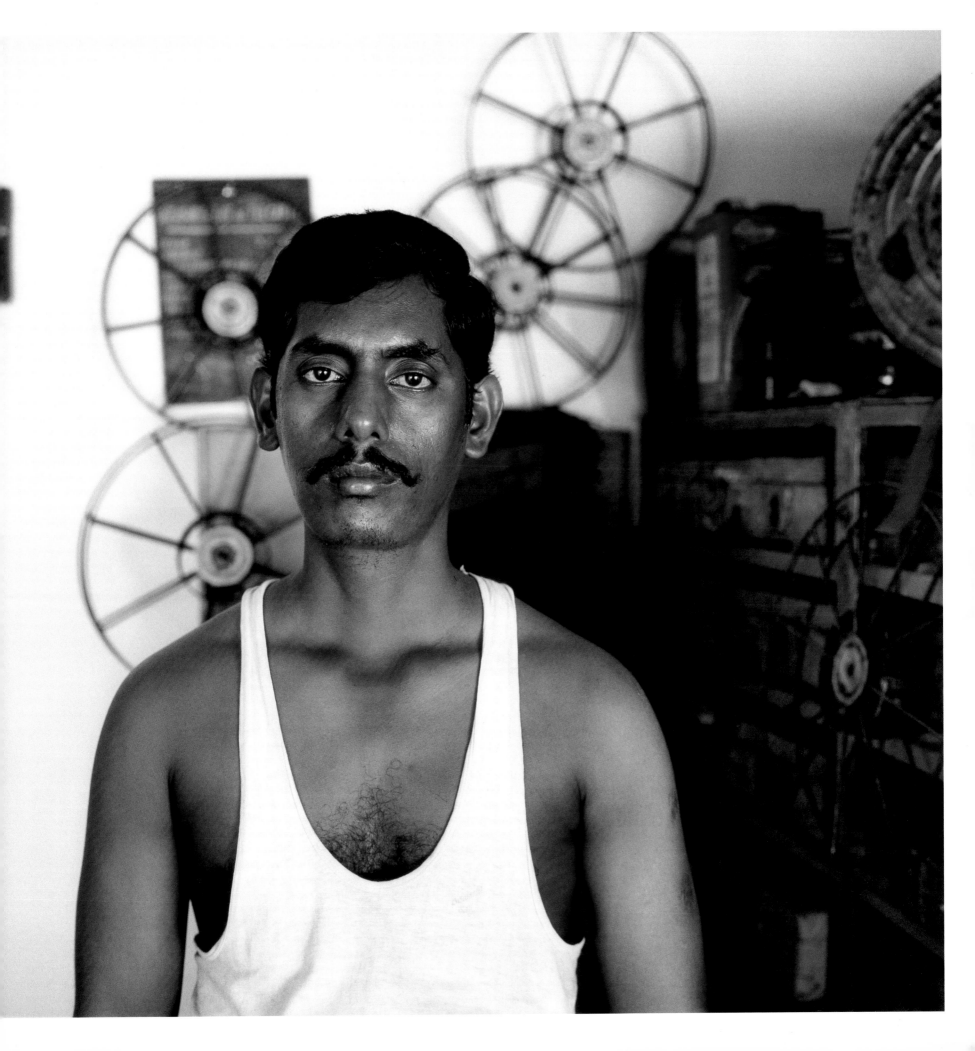

Chennai's Prarthana Drive-In Beach Theatre is the only drive-in cinema in southern India. Many viewers prefer to sit outside their cars in chairs that they bring along with them. Chennai has its own thriving film industry, with films made in the Tamil language.

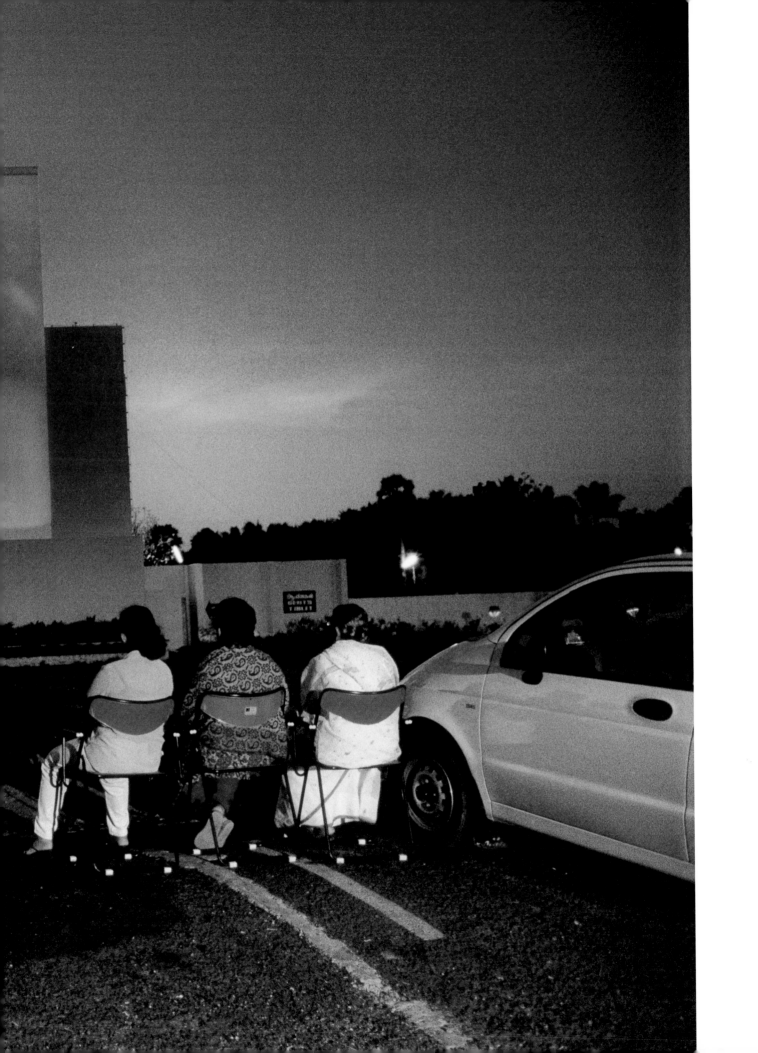

Acknowledgements

For the following people and organizations in India who went beyond expectations to make this photographic journey successful: Manisha Koirala, Jackie Shroff, Anupam Kher, Mahendra Verma, Indu Mirani, Leo Mirani, Ralphy Jhirad, N.D. Rangan, Dr N. Devanathan, the Government of India Tourist Office, Air India, and M. Rafiullah at Maharashtra Film, Stage & Cultural Development in Film City, Mumbai.

My deepest appreciation to all the actors, technicians, directors, producers, cinema owners, and movie-goers who allowed me to photograph them and who appear in this book.

A very special thanks to Audrey Jonckheer from Kodak for supporting this project from its very beginning stages, and for becoming a true friend. Thank you for believing in this project.

This project would not have been possible without continuous support from KODAK PROFESSIONAL.

I would like to extend my appreciation to Stephen Cohen at the Stephen Cohen Gallery, and Alan Klotz and Janet Sirmon at the Klotz/Sirman Gallery for their support and belief in this work.

I would like to thank the following people for their friendship, support and faith in my work: David Friend, Nick Hall, Tom Reynolds, Robert Peacock, Howard Greenberg, Celina Lunsford, Enrica Vigano, Alison Morley, Stephanie Heiman, James Wellford, Sarah Harbutt, Michelle Molloy, Simon Barnett, Ed Rich, Cheryl Newman, Elinor Carucci, Bill Hunt, Katie Webb, Susan Miklas, Jean-Francois Leroy, Meredith Kennedy, Preminda Jacob, Mira Nair, Bert Sun, Netta Navot and Geula Goldberg.

My gratitude goes to Richard Schlagman, Amanda Renshaw, Noel Daniel, Fran Johnson, Gudrun Hughes and Julia Joern at Phaidon Press for making this book possible, and to Nasreen Munni Kabir for her wonderful text and advice on India's cinema culture.

My thanks to Frederic Brenner for always stimulating and challenging me, and for encouraging me not to give up. My warmest thanks to Elaine Matczak, my long time friend, teacher and source of inspiration, for her valuable advice and encouragement and her active presence at every stage of this project. To my dearest friends Gadi Dotan, Jonathan Saacks, Assaf Lerman, Ziv Koren, Yoni Koenig and Tsadok Yecheskeli, thank you for your unconditional friendship and for being there for me.

I am most grateful to Karl, Liz and Jonathan Katz for their love, their generosity and for being family to me. Thank you Karl for all your help, advice and creative direction.

To my parents Virginia and Efraim and my sister Dana for their unconditional love, support and encouragement throughout my life.

To my wife and best friend, Tali, for always being supportive and patient, and for being my best creative advisor, editor and listener. Your sensitivity and creativity gave me comfort during the most difficult hours. My true friend and love. Thank you.

Phaidon Press Limited
Regent's Wharf
All Saints Street
London N1 9PA

Phaidon Press Inc.
180 Varick Street
New York, NY 10014

www.phaidon.com

First published 2003
Reprinted in paperback 2004
© 2003 Phaidon Press Limited

ISBN 0 7148 4456 X

Designed by SEA Design
Printed in China